Cruisers

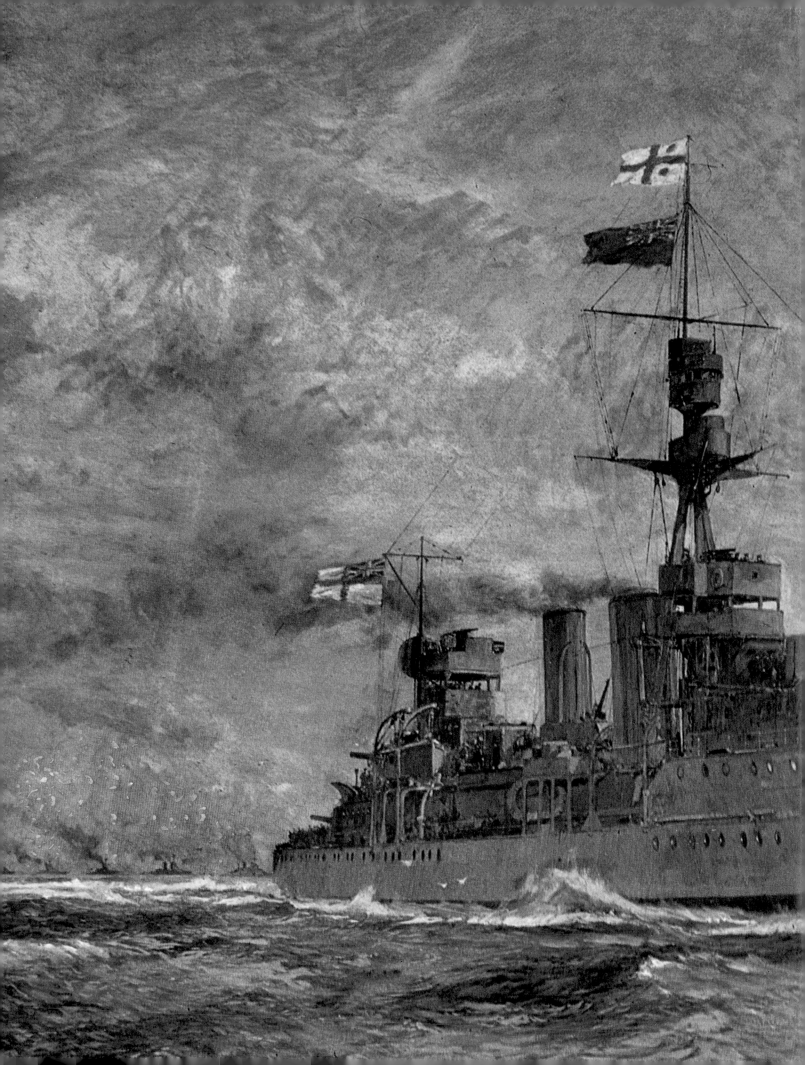

Cruisers

ANTONY PRESTON

BISON BOOKS LIMITED

This edition published in the USA for
K Mart Corporation
Troy, Michigan 48084

Copyright © 1982 Bison Books Inc

Produced by Bison Books Inc
17 Sherwood Place,
Greenwich CT 06830, USA

ISBN 0-86124-064-2

Printed in Hong Kong

CONTENTS

1 Eyes of the Fleet 6
2 Distant Oceans 10
3 In the North Sea 16
4 Lessons of Jutland 24
5 Treaty Limitations Imposed 28
6 Treaty Limitations Avoided 32
7 Convoys and Commerce-Raiding 38
8 Across the Pacific 10
9 Missiles and Nuclear Power 54
Index 64
Acknowledgments 64

EYES OF THE FLEET

The cruiser has fought in many famous naval battles and yet few people could give an accurate description of her function as a warship. Even naval historians have difficulty in defining just what a cruiser does.

The word 'cruizing' was used in the eighteenth and early nineteenth century to describe independent operations by a single ship, unattached to any squadron. 'Cruizers' were usually frigates but often smaller sloops and brigs, and very rarely ships-of-the-line. The essential meaning of the word was a description of function, not a classification of a ship-type. These operations could be against privateers, or against an enemy's shipping, or they could be merely to provide a squadron with intelligence.

The term continued to be used when steam was introduced, but in the 1880s it came to be applied to a broader category of warships, smaller than the battleship and the big steam frigate. As their function was to operate independently they were correctly described as cruisers, but because they were sizeable warships, they came to be thought of as a separate category. By 1889 the last of the Royal Navy's big steam frigates had been rerated as cruisers on the Navy List and a new category of warship was created.

As a cruiser's main task was to catch commerce-raiding warships and to prey on enemy shipping, speed was important. The engines of the day were cumbersome, and it was necessary to carry masts and yards as well, to save coal on long passages. This in turn limited the amount of armor which could be applied. In the 1870s and early 1880s the British and Russians both tried

to produce classes of 'belted' cruiser, but the weight of wrought-iron armor was so great that the narrow armored belt was submerged when the ships were at their load draught. Thereafter designers restricted themselves to providing an arched steel deck, which protected the machinery and magazines from shell fire.

As early as 1871 the British industrialist, Sir William Armstrong, realized that guns and shells would defeat side armor. Since armor could not produce invulnerability, weight could be devoted to armoring the bows, while watertight compartments could limit flooding elsewhere. In 1879 Armstrong's shipyard received orders for gunboats from Chile and China. In this trio Armstrong's ideas were developed: two heavy guns and a partial deck over the machinery; boilers and magazines below the water line.

The next stage was a Chilean cruiser, the *Esmeralda*, a ship which made Armstrong's fortune, led to an increase in the speeds of warships and ultimately caused sails to be abandoned. The *Esmeralda* had a complete deck instead of the earlier partial deck, and as she also carried two single 10-inch guns she created a tremendous impression of fighting power on a modest displacement.

The *Esmeralda* proved to be a poor seaboat, with freeboard sacrificed in favor of gunpower. Nor was the armor as thick or the endurance as great as claimed. However, for small navies prestige and reputation counted for at least as much as actual capabilities.

The French broke away from the 'protective deck' concept in 1888, when they designed the *Dupuy de Lôme*. The designer Emile Bertin was able to armor the whole length of water line with a narrow belt. A protective deck was also provided, to stop shells which plunged over the top of the belt, and below it was

Above: A *San Francisco* Class heavy cruiser alongside a repair ship in the Pacific during World War II.
Left: The French light cruiser *Gloire* seen in 1943 in an unusual camouflage scheme applied during a refit in the United States.

another partial thin deck to catch any splinters penetrating the main deck. Coal stowed between these decks provided further protection, while the watertight compartments were filled with cellulose, which was meant to swell and fill any holes made by shell-hits. The *Dupuy de Lôme* caused a great sensation when she appeared in 1893, and inspired the French Navy to build a new series of fast commerce-raiding cruisers.

The next step was to concentrate the armor over more important areas. The result was that a new type of cruiser appeared: the 'armored' as opposed to the 'protected' cruiser. Predictably it was Armstrong's yard which seized the opportunity when building a new *Esmeralda* for Chile. Unlike previous cruisers she had a narrow water-line belt of 6-inch armor in addition to her protective deck, and carried single 8-inch quick-firing guns on the forecastle and stern. She was hailed as the most powerful warship in the world, and it was claimed that her two 8-inch and sixteen 6-inch guns delivered a greater weight of shells per minute than the most powerful battleship afloat.

The *Esmeralda* came close to the French idea of a commerce-raiding cruiser, but the next Armstrong cruisers were definitely more powerful. The Chileans ordered the *O'Higgins* in 1896 before the *Esmeralda* had started her trials. She was given four single 8-inch guns and a heavy secondary battery of 6-inch and 4.7-inch guns. Her vitals were protected by a 5–7 inch belt.

The *O'Higgins* proved to be what Armstrong's customers wanted and Japan ordered the *Asama* and *Tokiwa* shortly afterwards, followed by the similar *Idzumo* and *Iwate* in 1898. These four were to form the backbone of the Imperial Japanese Fleet during the war against Russia and their outstanding performance did much to foster inflated ideas of the armored cruiser's worth.

The heroic work done by the eight modern armored cruisers at Tsushima might have guaranteed the type a long lease of life, but already events were in train which would reduce them to obsolescence. In 1904 Admiral Fisher became the Royal Navy's First Sea Lord and immediately set up a Committee on Designs to give effect to his ideas for new ships. The most revolutionary was his battleship *Dreadnought*. The secret of *Dreadnought*'s high speed of 21 knots was the adoption of the relatively untried Parsons turbine, and Fisher decided to produce a *Dreadnought*-equivalent of the armored cruiser, to fulfill the same role as the older type. This new armored cruiser was to have 12-inch guns, to enable her to fight battleships on more equal terms. Naturally 25 knots could not be achieved on the same displacement as *Dreadnought* without some sacrifice. One twin 12-inch gun mounting had to go and armor was restricted to the same 6-inch armor belt as the existing cruisers. Fisher claimed that the ships' speed would enable them to 'keep out of trouble.'

The new ships certainly fulfilled their designers' requirements when they made 25.5 knots on trials. They virtually killed off the old armored cruiser and for a while there was even talk of the smaller cruiser disappearing. The principal roles envisioned for them were to scout ahead of the battle fleet, to run down and destroy enemy armored cruisers on the trade routes and to finish off crippled battleships in a fleet action. The value of 12-inch guns in the last two roles was questionable, but for the scouting role it was claimed that 12-inch guns would enable these ships to push a reconnaissance past a screen of cruisers, and get within gun-range of the enemy battle line.

The term 'dreadnought armored cruiser' was too cumbersome to last and in 1913 the term 'battlecruiser' was coined. It was, with hindsight, an unfortunate choice, for it suggested a ship of capital rank, whereas a look at the design of *Invincible* reveals that she was no more than a turbine-driven cruiser, armed with four twin 12-inch gun turrets. It was not foreseen that the battle-cruisers would be mistaken for fast battleships, which they most definitely could not be. This confusion of title and function was to have tragic consequences.

The glamor of the *Dreadnought* and the *Invincible* Class focused attention on major warships but the traditional cruiser was still important. The protected cruiser had been divided into

three types: 1st, 2nd and 3rd Class, ranging from ships as powerful as armored cruisers down to vessels little better than gunboats. The term 'scout' came into vogue at the turn of the century for the latest 3rd Class cruisers and for a while the Royal Navy built no other cruisers.

Other navies showed a declining interest in smaller cruisers, preferring to build very big armored cruisers. The knowledge that Germany was continuing to build small cruisers was sufficient warning to the British that they must stay in the game. In 1908 work began on a new design, despite Fisher's dislike of cruisers, and the first of the class was ready at the end of 1910. The *Bristol* Class ships were a great improvement over the scouts, being bigger and sturdier. With experience gained from the scout *Amethyst*, the *Bristol* Class ships were driven by steam turbines at 25 knots. This equalled the speed of the scouts. The extra 1000 tons of weight were used to provide an armored deck and two 6-inch guns, in addition to ten 4-inch guns.

On paper contemporary German cruisers were superior, with a small patch of splinter-proof side armor over the machinery and boilers and a two-knot advantage. Maximum speed, however, was achieved by overload and in practice they were only good for 25 knots. Although it was widely believed that the German 4.1-inch gun could outrange the British 6-inch gun, and that the lighter shell allowed a higher rate of fire, time was to show this was fallacious. In practice the heavier British gun could not only outrange the 4.1-inch and inflict more damage, but could also shoot more accurately at extreme range.

Both sides continued to build small cruisers, but the Germans clung to the idea of a large number of light guns while the British moved on to a much heavier armament. The next class after the *Bristol*, were very similar but dropped the 4-inch guns and had a uniform armament of eight 6-inch, as well as a longer forecastle for seaworthiness. In the next design the forecastle was extended two-thirds of the length of the ship, allowing five of the eight 6-inch guns to be mounted at maximum height. In this *Chatham* Class the British finally achieved the sort of cruiser they wanted, with sufficient endurance to hunt down commerce-raiders yet with sufficient speed and armament to serve as fleet scouts.

The United States Navy had not followed a very coherent policy of cruiser-building. Going back as far as the War of Independence, individual American warships had achieved great fame as commerce-raiders, and there was a natural tendency to think in terms of fast cruisers for this single purpose. There was also the problem of severe financial stringency. Even when the threat of war with Spain caused money to be spent, it tended to be spent on capital ships, rather than cruisers. The Americans had no vast seaborne trade to protect and so there was no compulsion to build anything like the standard 2nd Class cruisers which British shipyards turned out in large numbers in the 1890s.

The French stopped building small cruisers in the mid-1890s, having convinced themselves that the whole *raison d'etre* of a navy was to operate against commerce rather than fight an enemy fleet. Developments of the *Dupuy de Lôme* were built in considerable numbers, but in spite of their imposing appearance they were not good steamers and not particularly well protected.

The Japanese were closely associated with the British, and so they tended to follow Royal Navy ideas. As their armored cruisers had behaved so well at Tsushima they decided to go ahead with plans for building improved types. The war with Russia accelerated the plans, for the Japanese Diet wanted to ensure that the Navy would not be too weakened by war losses to deter any other aggressors. Armored cruisers could be built faster than battleships and so the keel of the first ship, the *Tsukuba* was laid in January 1905. She and her sister *Ikoma* were built at Kure. They were the most heavily armed cruisers of their day with 12-inch guns in two twin turrets, a dozen 6-inch and another dozen 4.7-inch. Although not as fast as some foreign armored cruisers, 20.5 knots gave them a good margin over contemporary battleships.

The British, having created the successful 'Town' Class,

decided that a new class of smaller cruiser was needed to work with destroyers. In 1912 the decision was made to produce a new intermediate type, more powerful than the scouts, five knots faster and carrying two 6-inch guns. The *Chatham* and *Birmingham* Classes had introduced a small strip of water-line armor, intended to keep destroyer-sized shells from penetrating boiler-rooms and machinery spaces. This feature was incorporated into the new cruisers in a much improved form.

Normally armor plates were bolted to the hull, which had to be strengthened to take this additional 'skin' but in the new cruisers it was decided to build the hull with a longitudinal strake of high-tensile steel in addition to the normal 1-inch side plating. In effect this made the armor part of the hull and provided sufficient structural strength to allow the rest of the hull to be lighter. Weight was also saved by using destroyer-type fast-running turbines and boilers and by providing oil fuel. Previously coal had been used in all cruisers, but oil has greater thermal efficiency and so the weight saved could be used for higher speed.

The British also established a precedent by abolishing the cumbersome system of grading cruisers into scouts, 1st, 2nd and 3rd class, protected and armored, etc. Instead the armored cruisers and big deck-protected cruisers were lumped together as 'cruisers,' while all the old protected cruisers, the scouts, 'Towns' and the new *Arethusa* Class became 'light cruisers.' Exactly where the dividing line came was not laid down, but there was a general consensus that light cruisers had guns up to 6-inch caliber, whereas the bigger ships had guns of higher caliber. Significantly the hybrid battlecruisers were no longer

included in the cruiser-category, all navies having come to accept them as capital ships ranking just below battleships.

When war broke out in August 1914 the 360-odd cruisers in the world were a collection of ancient and modern. The Royal Navy led the world with 114 of all sizes. Battleships being so prestigious it was inevitable that much of the fighting would have to be done by smaller units, and this provided the cruiser with its rationale. The cruiser was still the largest warship which could be built in reasonable numbers, and she would therefore be called on to perform the widest variety of tasks.

Above: the USS *St Louis* rigged for coaling in 1918.
Below: The armored cruiser St Louis circa 1911 while flagship US Asiatic Fleet.

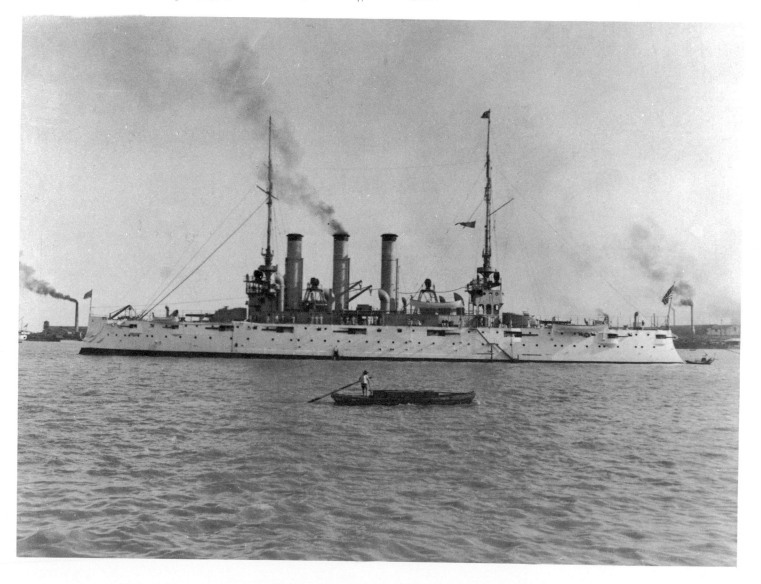

DISTANT OCEANS

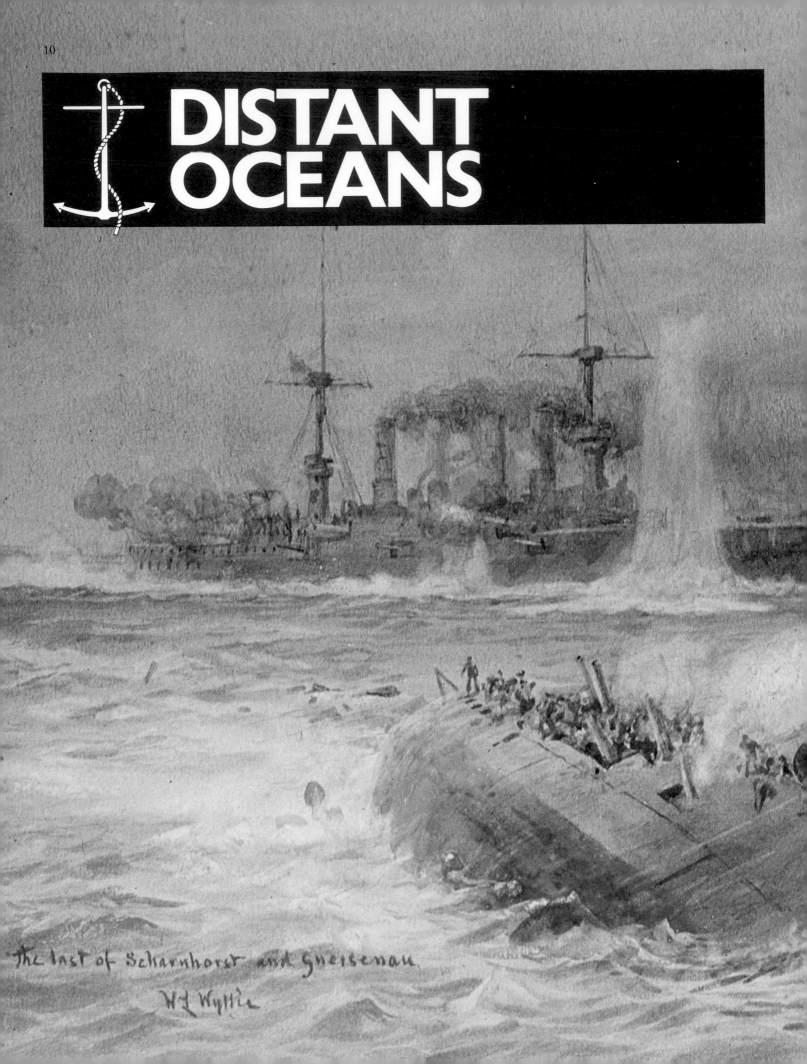

The last of Scharnhorst and Gneisenau

W L Wyllie

The opening weeks of World War I seemed to confirm prewar notions about how navies would function. There were a number of German cruisers in the Far East and a small Austro-Hungarian squadron. The German ships were the modern armored cruisers *Scharnhorst* and *Gneisenau* and the light cruisers *Emden*, *Dresden*, *Leipzig* and *Nürnberg* under the command of Vice-Admiral Maximilian von Spee, flying his flag in the *Scharnhorst*.

A month before the outbreak of war von Spee took his squadron to the South Pacific, leaving Fregatten-Kapitän von Müller in the *Emden* at Tsingtao, the German base on the southern coast of China. As soon as the news of impending war was received von Müller put to sea ready to harass enemy shipping in the Far East. In the meantime the base prepared colliers and supply ships to replenish the main squadron in the South Pacific.

Von Spee chose to take his ships to the coast of South America, close to neutral harbors where he could continue to get coal, and well out of the way of the powerful Japanese Navy. However he decided that it was still worth sending one cruiser into the Indian Ocean to cause disruption. The *Emden* had joined the squadron on 12 August and as the fastest ship was ideal for the task. So two days later she left the squadron and headed for the Palau Islands accompanied by a collier.

From the Palaus the *Emden* went south and then west, taking care to hide her true destination as far as possible. When she reached the Lombok Strait von Müller decided that it was time to adopt a disguise, and soon the ship sported a fourth funnel made of wood and canvas. The result was that she reached the Bay of Bengal unrecognized by the British, French and Japanese warships hunting for her.

The first capture was made on 10 September, a Greek collier which was pressed into service to serve the *Emden*'s needs. During the following week another five ships were captured; four were sunk and the fifth was used to transport the prisoners. Despite this the Allies did not know the *Emden* was in the area until a neutral Italian merchantman reported that she had been stopped and searched. The news was sufficient to bring trade to a standstill.

The cause of all this havoc was no longer in the area, having slipped away to look for targets off Rangoon before doubling back. On 22 September she stood about two miles offshore and bombarded the oil storage tanks at Madras. Two were set ablaze, three more were damaged and random shots fell in the city and damaged shipping in the harbor. It was a blow to British prestige and all shipping came to a halt only a day after it had restarted.

The culprit disappeared from the scene in as mysterious a fashion as she had arrived and then twisted the British lion's tail again by calling at Diego Garcia. The people on this tiny island had not heard of the outbreak of war, and so they welcomed the *Emden* and permitted the crew to relax ashore and carry out minor repairs. Still the *Emden*'s luck held and she sank four more ships off Ceylon. Von Müller next planned a raid on Penang on the west coast of Malaya, where he expected to find a large number of merchantmen.

With her dummy funnel rigged the *Emden* was approaching Penang just after 0800 on 28 October when her lookouts made out

A dramatic view of the Battle of the Falkland Islands. The *Scharnhorst* succumbs to the British fire while the *Gneisenau* tries to fight on.

a string of lights to starboard. They belonged to the Russian light cruiser *Jemtchug*, but the Russian lookouts failed to see the strange cruiser gliding closer and closer. At a range of only 300 yards the *Emden* fired a torpedo from her starboard submerged tube; it ran true and detonated below the *Jemtchug*'s after funnel. The Russians gamely tried to reply and one gun actually returned the fire, but the *Emden*'s broadsides completed the devastation. A second torpedo finished the Russian ship off and when the smoke cleared only the *Jemtchug*'s mast was visible above water.

Von Müller now turned northwards, deciding that it was time to get clear. Still he could not resist the temptation to stop a British merchantman before leaving, but while his prize crew was boarding the lookouts sighted a strange warship. It was the French destroyer *Mousquet*, determined to try to stop the *Emden*. Although hopelessly outclassed the little destroyer put up a brave fight before she was overwhelmed.

Now the odds were shortening, for the British and Japanese were determined to catch the *Emden* and had 15 cruisers available. Von Müller decided to destroy the cable station in the Cocos-Keeling Islands in the southwestern Pacific. As well as interrupting communications between Australia and Great Britain, he intended to decoy some of the Allied cruisers away from the Indian Ocean. It was apparently his intention to elude his pursuers and slip back into the crowded shipping routes, but this time his luck was out. Although the *Emden*'s radio was tuned to the same frequency as the station at Port Refuge to jam any transmissions, the British operator managed to transmit 'Unidentified ship off entrance' before the landing party started to wreck the installation. Shortly afterward the *Emden* picked up a transmission from an unknown warship but as she was estimated to be 250 miles away there seemed to be no need to worry.

However the message had been picked up by a force of Allied cruisers escorting a troop-ship convoy, and the Australian *Sydney* had been detached to investigate. She was only 52 miles away and her smoke was sighted at about 0900 hours, three hours after the *Emden*'s arrival. The Germans were in the worst possible position, taken by surprise with 46 officers and men ashore at the cable station. In his report Captain Glossop of the *Sydney* noted that the *Emden* replied to his fire at 10,000 yards, but as his own 6-inch guns had no difficulty in shooting at 14,000 yards this was easily dealt with. Even more important was the protection given by the narrow strip of waterline armor which entirely defeated the *Emden*'s 4.1-inch shells at 8000 yards. It was also noted that the German shell seldom burst whereas the *Sydney*'s caused terrible damage. By 1045 *Emden*'s fire was becoming feebler as casualties and damage mounted. With two funnels demolished and the foremast blown over the side she was rapidly being reduced to a wreck and von Müller decided to run her ashore on North Keeling Island. After a brief respite, when the *Sydney* turned away to catch the escaping collier, the attack started again. Von Müller wished to surrender, but all signal books had been destroyed and it was impossible to reply. After a

further five minutes of slaughter someone finally found a white flag and the *Emden*'s ordeal was over. She had lost 134 killed and 65 wounded, against three killed and 13 wounded in the *Sydney*.

The cruise of the *Emden* has never been equalled as an example of cruiser warfare, not only for her success in travelling 30,000 miles and sinking 70,000 tons of shipping, but also for the chivalry and ingenuity of Karl von Müller. By her exploits she disrupted important shipping and tied down a large number of enemy warships.

The fate of the rest of the Far East Squadron was even more dramatic. Von Spee took his ships to Chilean waters where on 1 November he encountered a British squadron under Rear-Admiral Cradock. The British squadron included two elderly armored cruisers, the *Good Hope* and the *Monmouth*, a modern light cruiser HMS *Glasgow* and an armed merchant cruiser, the ex-liner *Otranto*. Six years earlier the *Good Hope* had been the crack gunnery ship of the Channel Fleet, but now she and the *Monmouth* were manned for the most part by reservists and were ill-fitted to face the *Scharnhorst* and *Gneisenau*. The British flagship had two single 9.2-inch guns and sixteen 6-inch and the *Monmouth* had fourteen 6-inch; the two German ships were each armed with eight 8.3-inch (21cm) and six 5.9-inch (15cm) guns.

If Cradock seems rash in his anxiety to court destruction, one must remember certain points. First, the cruise of the *Emden* had shown what havoc could ensue from a well-handled commerce-raiding cruiser. Second, another cruiser-admiral, Troubridge, had just been severely censured for failing to risk his ship in battle against what he judged to be a superior force. With this in mind Cradock lodged a letter with the British Consul at Valparaiso saying that he did not intend to be accused of any dereliction of duty. A third, and even more valid argument, was the

The USS *Columbia* seen in Hampton Roads in December 1916. The *Columbia* became known for her high coal consumption.

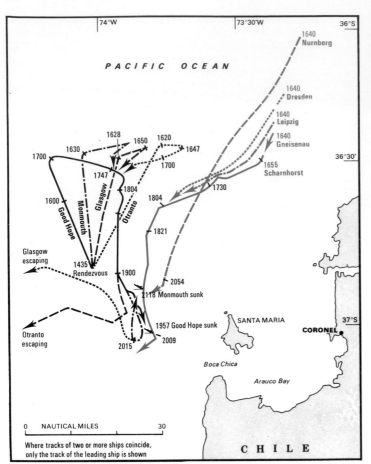

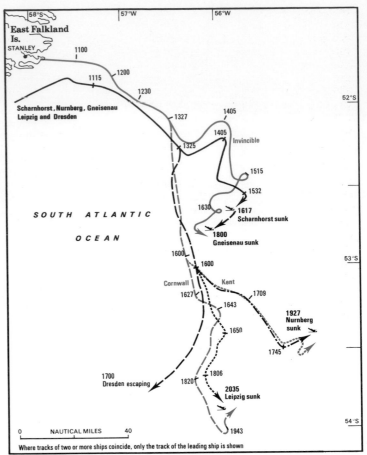

Above the Battle of Coronel, 1 November 1914.
Above right: The Battle of the Falkland Islands.

possibility of inflicting damage on von Spee's ships. At such a distance from a main base all but the slightest damage would seriously impair a raider's efficiency.

The Battle of Coronel was a one-sided affair. Cradock's ships were silhouetted against the setting sun while von Spee's were difficult to pick out in the fading light, making it impossible to equalize the disparity in gunpower. Cradock ordered the slow *Otranto* to stay clear of the battle and gave the captain of the speedy light cruiser *Glasgow* discretion to get clear if the squadron was overwhelmed. In the grim knowledge that they could not escape, the two British armored cruisers turned to face the five enemy cruisers. The action began at 1900 as the sun set. An hour later both ships were helpless wrecks, and they sank with the loss of all hands. The *Glasgow* escaped with little more than splinter damage, for von Spee's ships had concentrated their fire on the *Good Hope* and *Monmouth*.

Cradock was attacked posthumously for not falling back on the *Canopus*, a slow but powerful old battleship which was in support, but if von Spee's squadron had disappeared Cradock would have been bitterly criticized for not bringing him to action. Although von Spee's ships had suffered no damage they had used a lot of ammunition and this could not be replaced.

Von Spee now decided to attack the tiny British coaling station in the Falkland Islands, on the other side of the continent. The decision was a fatal mistake, but in the world of 1914, as in 1982, such gestures counted for a lot and von Spee may also have thought that it was the least expected of all the moves open to him. However the British knew that they had blocked his escape route to the Panama Canal with a powerful Anglo-Japanese squadron, had covered a move back to the central Pacific with another squadron and had sufficient ships in the South Atlantic to prevent a raid on the River Plate shipping.

Not content with this massive concentration the Admiralty

released two battlecruisers from the Grand Fleet, the *Invincible* and *Inflexible*, to be sent to the Falklands to reinforce the cruisers. Correctly divining that von Spee would want to break into the Atlantic for an eventual return to Germany, but also guessing that he would avoid the Panama Canal because it would give away his whereabouts, the British were taking no chances. The *Canopus* was ordered to put herself aground on the mud flats to act as a gun battery in defense of Port Stanley.

The battlecruisers sailed on 11 November, only 10 days after Coronel. They met a cruiser force led by Admiral Stoddart off the coast of Brazil and reached Port Stanley on the night of 7 December. They were just in time, for at 0800 next morning, while the ships were still taking on coal, lookouts reported that von Spee's ships were in sight. It was an anxious moment for the British admiral, Sturdee, for if von Spee had maintained speed he might have been able to engage the British ships one by one as they came out of the harbor. However the German lookouts spotted the gaunt outline of four tripod masts through the murk. This could only mean dreadnoughts, either battleships or battlecruisers, and von Spee knew that he was doomed.

The *Canopus* fired a few shots to discourage an approach to the harbor, and the two leading German ships immediately turned back with their terrible news. The British armored cruisers already had steam up and they weighed anchor as fast as they could but it was 1000 before the two battlecruisers could get clear. Von Spee's ships had about 15 miles' start but they had not docked for some time and their hulls were foul with marine growths. The British settled down to a long stern chase, content to spend the rest of the morning overhauling their prey.

Just before 1300 the *Leipzig* began to drop behind and the *Inflexible* opened fire on her at 16,000 yards. To try to save his smaller ships von Spee turned back with *Scharnhorst* and *Gneisenau*, giving his light cruisers orders to scatter. With a

speed advantage of several knots as well as a massive preponderance of gunpower, the two battlecruisers managed to prevent the armored cruisers from closing and contented themselves with firing at very long range. The result was a long drawn out battering for the *Scharnhorst* before she sank at 1617 while the *Gneisenau* lasted until 1800 hours. Only 200 survivors were picked up.

The light cruisers had been left to Stoddart; the *Kent* went after the *Nürnberg* while the *Cornwall* and *Glasgow* chased the *Leipzig*, omitting in the confusion to mark the *Dresden*. The 14-year old *Kent* exerted herself to catch the *Nürnberg*, although her claimed feat of reaching 25 knots was an exaggeration, while the *Glasgow* and *Cornwall* had less trouble catching the *Leipzig*. By nightfall von Spee's squadron was no more, with only the *Dresden* surviving to hide among the islands of Tierra del Fuego. The *Bristol* and an armed merchant cruiser rounded up all the German colliers as well to make the victory complete. The *Dresden* was caught three months later by the *Kent* and *Glasgow*. Seeing that escape was impossible her captain scuttled her to avoid capture.

Two more cruisers had been at large, the *Königsberg* and *Karlsruhe*, but in November 1914 the *Karlsruhe* sank after a boiler explosion, 200 miles east of Trinidad. The *Königsberg* was swiftly trapped in her lair in the Rufiji River in East Africa by the cruiser *Chatham*. Her career as a raider had been brief but eventful; on 20 September she had caught the smaller cruiser HMS *Pegasus* lying at Zanzibar with her boiler-fires drawn and had sunk her as easily as the *Emden* had sunk the *Zemchug* at Penang. She was not finally destroyed until July 1915, by special shallow-draught river monitors sent out from England.

Below: The *Gneisenau* (shown here) and her sister the *Scharnhorst* were built in 1904–08. Their design benefitted from analysis of the Tsushima battle.

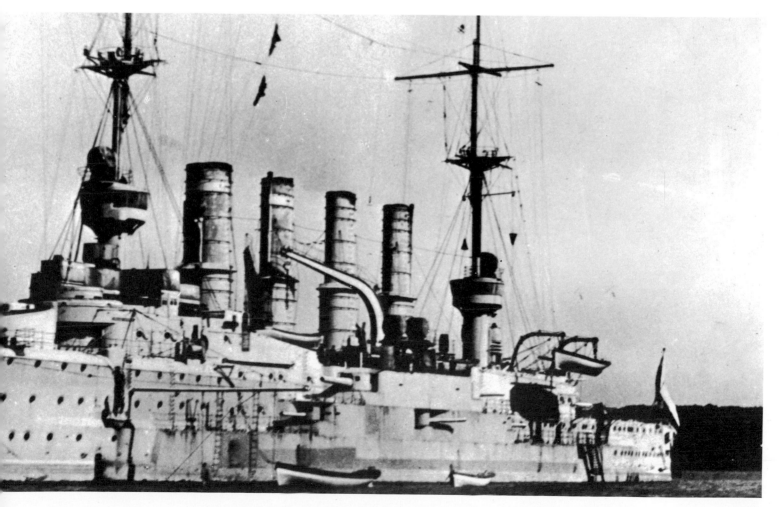

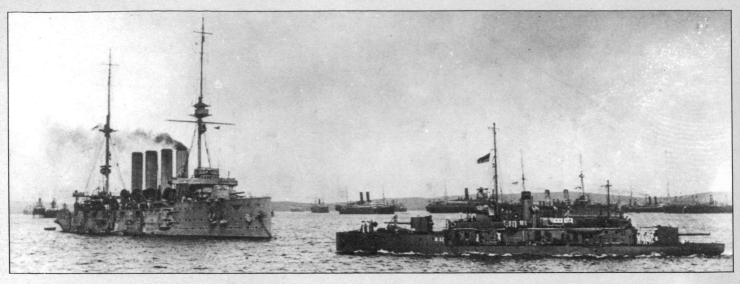

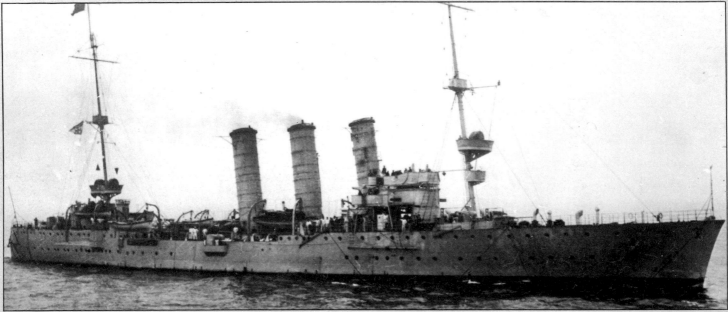

Above: SMS *Berlin* was completed in 1905 and was converted to serve
as a minelayer in the early part of the war.
Top: The armored cruiser HMS *Bacchante* at Mudros in 1915. The
monitor *M.23* moves slowly past.
Below: HMS *Aurora* of the *Arethusa* Class. The *Arethusa* Class
displaced 3530 tons and carried two 6-inch and six 4-inch guns at a
maximum speed of around 29 knots.

IN THE NORTH SEA

While German and Allied cruisers were chasing one another around the trade routes their sisters were in action closer to home. By an exasperating series of errors the British Mediterranean Fleet let the German battlecruiser *Goeben* slip through their fingers after having her literally in their sights. Rear-Admiral Troubridge, commanding a squadron of four modern armored cruisers, refused to engage the *Goeben* and the light cruiser *Breslau* on the grounds that his orders prohibited engaging a superior force. Not even the skilful pursuit by the light cruisers *Gloucester* and *Dublin* could offset the disgust felt by the Royal Navy for such a paltry excuse and Troubridge's career was ruined. In the light of what happened at the Falklands four months later it is ludicrous to suppose that the *Goeben* and *Breslau* could have picked off the *Defence, Warrior, Duke of Edinburgh* and *Black Prince*, the two light cruisers and 10 destroyers at will.

The *Goeben* and *Breslau* reached Constantinople in due course and their arrival convinced Turkey that the time was ripe to enter the war on Germany's side. The two ships became *Yavus Sultan Selim* and *Midilli* respectively on 16 August, but continued to be effectively under German control. On 27 October they sortied from the Bosphorus to attack Russian ships and thus dragged Turkey into war with Russia as well. The Russian Black Sea Fleet was relatively weak but it was handled energetically and cruisers on both sides fought in a number of skirmishes.

In the North Sea events moved equally swiftly. A cruiser, the scout HMS *Amphion*, became the first naval casualty of the war only 13 hours after the outbreak while leading a flotilla of destroyers from Harwich to intercept a mysterious steamer seen 'throwing things overboard.' After sinking the auxiliary mine-

layer SMS *Königin Luise*, she ran into the minefield laid the previous day. The explosion blew away the *Amphion*'s forecastle and when a second mine set off the magazine she sank rapidly.

On 28 August the British took the initiative and sent a powerful force into the Heligoland Bight to test the German defenses. The spearhead was the scout *Fearless* and the new 'light armored cruiser' *Arethusa* with 32 destroyers. As intended the German light forces came out to protect their torpedo boats, and soon the *Stettin* and *Frauenlob* were hotly engaging the British forces. The *Arethusa* was having trouble with her 4-inch guns, which were of a new type, and after receiving 35 hits was reduced to one 6-inch gun. At 1030, when the sweep should have been over, she was still trying to get her guns working and carrying out minor machinery repairs. The German light cruiser *Strassburg* loomed out of the mist and for a while it looked as if the *Arethusa* might be sunk, but in the nick of time four 'Town' Class cruisers under Commodore Goodenough arrived and drove off the attackers. However, further German reinforcements were hurrying out and once again the tide of battle swung against the British. Fortunately for them, a destroyer put a torpedo into the light cruiser *Mainz* and then five battlecruisers under Vice-Admiral Beatty arrived. Their impact on the action was swift and decisive, the *Köln* and *Ariadne* being sunk in short order and the *Frauenlob*, *Strassburg* and *Stettin* damaged.

The British forces prudently withdrew at this juncture, having taken enough risks for one day. They had inflicted heavy casualties and suffered comparatively lightly in return and the effect on German morale was far-reaching. The Kaiser immediately forbade any sorties which might lead to losses and the Naval Staff was forced to agree to a defensive policy. The result was that British light forces gained the ascendancy in the North Sea.

A Harwich Force, comprising light cruisers and destroyers under Commodore Tyrwhitt, was stationed to guard against any attempt by the High Seas Fleet to enter the English Channel. From August 1914 a constant stream of soldiers and supplies passed across the Channel to France and the British knew how vulnerable this supply line was to surface attack. The Harwich Force was charged with the task of protecting it and Tyrwhitt interpreted this to mean that offense was the best form of defense. His forces were constantly on the move, in all weathers, and although the rate of attrition was high, throughout the four years of war German surface forces were only able to sink one empty transport in the Channel.

Action with light cruisers and destroyers could be a terrifying and hectic business and the outcome was largely a matter of luck. There was the constant risk of being torpedoed, the hidden menace of mines and the hazards of operating in close formation at high speed. Tyrwhitt's flagship, the *Arethusa*, came to grief in

February 1916 in a newly-laid minefield off Harwich and although the sturdy little cruiser did not sink, the tow parted in rough weather, allowing her to drift onto a shoal. Eventually she broke her back and had to be written off. Tyrwhitt transferred his broad pennant to the *Cleopatra* and was back in action almost immediately. In March 1916 four light cruisers and ten destroyers escorted a seaplane carrier in an attempt to bomb Zeppelin sheds at Tondern. The following night the captain of the *Cleopatra* sighted a ship steaming past on the port bow and realized from the sparks billowing out of her funnels that she was a coal-burner and therefore German. Increasing speed the cruiser turned to starboard and suddenly two destroyers appeared across her bows. The *Cleopatra* rammed the second destroyer, the *G.194*, cutting her in two while the *Undaunted* opened fire with her guns. No survivors from the German destroyer were found.

The *Arethusa* Class proved ideal for close-range action of this kind. Their only weak point was the mixed armament and this was altered in succeeding classes. First the 4-inch guns were replaced by 6-inch and extra torpedo tubes, and then as the design was expanded more 6-inch guns were carried. By 1916 the latest variant, the *Centaur*, carried five 5-inch and eight 21-inch torpedo tubes, earning the nickname of 'Tyrwhitt's Dread-

noughts.' The Germans had been following the British trend toward more guns and their last prewar light cruisers, the *Frankfurt* and *Wiesbaden* were given a uniform armament of 5.9-inch guns. Wartime shortages meant that only six more of the class were completed.

The High Seas Fleet received four more cruisers during the war. Two Russian cruisers building at Danzig became SMS *Pillau* and SMS *Elbing* and four sets of steam turbines for a Russian battlecruiser were installed in two specially built minelayers. These were the *Brummer* and *Bremse*.

The Battle of the Dogger Bank, fought on 23 January 1915, showed that even a big modern armored cruiser like the German *Blücher* had no hope of standing up to capital ships' guns. The British light cruisers played their part in scouting for the battle-cruisers, with the *Aurora* making the first sighting report and the *Arethusa* helping to finish off the badly damaged *Blücher*. It was a classic example of how light cruisers could stiffen a destroyer attack, for the *Blücher* had crippled the leading British destroyer when the *Arethusa* arrived with the rest of the Harwich Force destroyers to cover the final torpedo attack which sank the German cruiser.

The Battle of Jutland on 31 May 1916 saw cruisers functioning just as they had been intended to, scouting for the battle fleet and

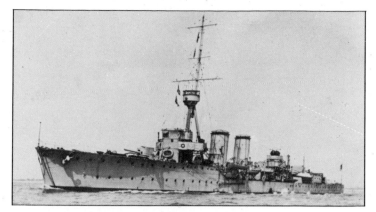

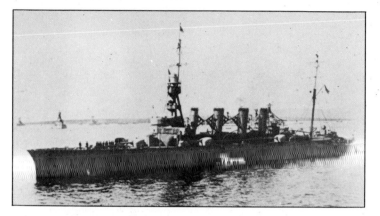

Top right: *Calliope* and her sister ship *Champion* were the first British light cruisers to have only two funnels.
Right: HMS *Birmingham* seen with baffles fitted to the funnels in the hope of confusing enemy range takers.
Below: SMS *Dresden* belonged to the last class of German light cruisers built during World War I. Of the ten ships planned only the *Dresden* and *Köln* were completed.

leading destroyers in attacks. There were no fewer than 45 cruisers of all kinds involved, 34 of them British. All three types were present on the British side, the armored cruisers acting as a heavy scouting wing of the Grand Fleet, the light cruisers and even four scouts attached to the battle squadrons. The Germans on the other hand had only light cruisers with the High Seas Fleet, some of them quite elderly.

Inevitably the first sighting was made by cruisers. A Danish ship blowing off steam in a position between the outer wing of each fleet attracted the attention of the German cruiser *Elbing* and the British *Galatea*. After months of fruitless sorties there was a noticeable exhilaration when the signal 'Enemy in Sight' was hoisted to the cruisers' mast heads. The only full-scale fleet action of the war was about to begin.

First blood went to the *Elbing*, with a hit below the *Galatea*'s bridge, but it failed to explode and Commodore Alexander-

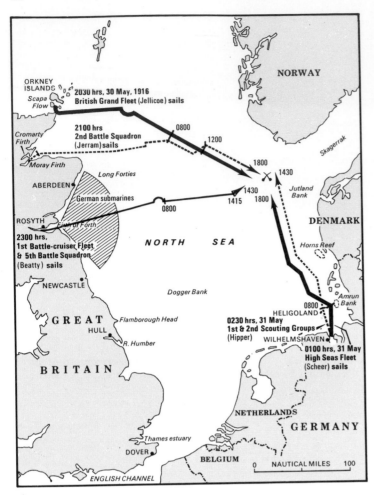

Sinclair's flagship turned away to try to entice the 2nd Scouting Group northward. His aim was to lead the whole enemy fleet north, allowing Beatty and the battlecruisers to get between it and its bases. However by doing this Alexander-Sinclair was failing in his first duty, that of forcing his way past the German cruisers to find out what force they were screening. Until that information was available Beatty could form no battle plan and the Commander in Chief, Admiral Jellicoe, could not coordinate movements with his subordinate. So for the moment Beatty could only try to engage the 2nd Scouting Group, in ignorance of the fact that Vice-Admiral Hipper and his battlecruisers were coming up in support. The German scouting was more methodical, although the *Elbing* reported the British light cruisers as battlecruisers, and a further report from her about recognition signals was misinterpreted as a sighting of 24 or 26 battleships! Thus Hipper received muddling information at the outset of the battle, and had no knowledge of the whereabouts of either Beatty or Jellicoe.

At 1529 *Galatea* caught sight of five columns of heavy smoke behind the pursuing German light cruisers, and interpreting them correctly as major warships steaming at maximum speed, signalled the course and bearing to Beatty. At 1548 the first shots were fired and it was time for the light cruisers to draw clear. In the first phase the *Indefatigable* blew up under heavy fire from the *von der Tann*, and Beatty ordered the light cruiser *Champion* and her destroyer flotilla to make a torpedo attack to relieve the pressure. In the meantime the battle was swinging back in Beatty's favor, as his four powerful fast battleships of the *Queen Elizabeth* Class had come up in support. Despite the loss of a second battlecruiser, HMS *Queen Mary*, the British salvoes were scoring more and more hits. On his own initiative Commodore

Left: The approach to the Battle of Jutland.
Below: Although the *Birmingham* suffered extensive damage at Jutland there were no casualties among the crew.

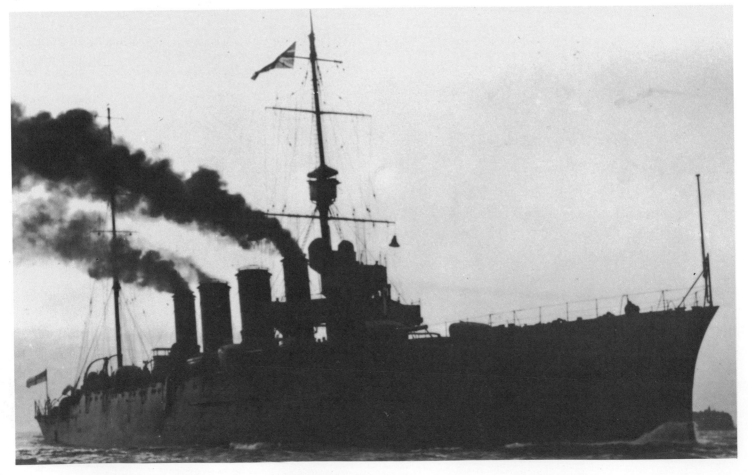

Heinrich in the light cruiser *Regensburg* ordered his destroyers and torpedo boats to attack Beatty's line and take the pressure off Hipper.

In contrast to the 1st Light Cruiser Squadron's misguided attempt at trailing its coat the 2nd Light Cruiser Squadron under Commodore Goodenough showed how light cruisers were meant to perform their job. Regardless of the danger, Goodenough pressed on southward until at 1633 he succeeded in closing to within 13,000 yards of the main body of the High Seas Fleet under Vice-Admiral Scheer, 22 battleships and their attendant destroyers. Because Goodenough kept his ships bows on they were mistaken at first for friendly ships, but as soon as they turned away their unmistakable four funnels gave them away and the German battleships opened fire. However, the four cruisers weaved their way through the 200-feet high splashes to safety, all the while sending out the vital signal, 'Have sighted enemy battle fleet, bearing southeast. Enemy's course north. My position 56 degrees 34 seconds north, 6 degrees 20 minutes east.'

Goodenough was only two miles ahead of the *Lion*, Beatty's flagship, when he made his momentous sighting, and so it was only a matter of minutes before the admiral could see for himself. Secure in the knowledge that his own Commander in Chief was in support, Beatty turned away and headed northwest, with Scheer and Hipper in pursuit. The Grand Fleet was disposed in cruising order with the 4th Light Cruiser Squadron and the destroyers forming an antisubmarine screen while the armored cruisers of the 1st and 2nd Cruiser Squadrons were eight miles ahead as a scouting screen. In addition Jellicoe had pushed his 3rd Battlecruiser Squadron under Rear-Admiral Hood in order to provide a rapid reinforcement for Beatty as soon as contact was made. With Hood were seven light cruisers. It must be remembered that without aerial reconnaissance scouting was the hardest job of all and visual contact was essential.

Precise news was just what Jellicoe did not get, for apart from Goodenough, none of the subordinate commanders seems to have understood the need to signal precise bearings and courses of any ships sighted. Captains tended to rely too much on the senior officer present to make all situations reports, a weakness which was compounded when the *Lion*'s radio equipment was shot away leaving Beatty unable to pass signals. After several attempts at getting coherent reports out of the battlecruisers Goodenough's detailed information came as a refreshing change. At 1630 Beatty's and Jellicoe's cruisers made contact at last, the *Falmouth* of Beatty's 3rd Light Cruiser Squadron and the armored cruiser *Black Prince* of Jellicoe's 1st Cruiser Squadron. Once again the reports were couched in terms which were unhelpful. Even the reliable Goodenough fell into a common trap when at 1750 he gave a bearing which was a 180 degree reciprocal of the correct one; in the heat of battle such confusion happens but some of the reports of the other commanders were consistently inadequate. All the time visibility was decreasing, with funnel-smoke adding to the gloom.

The final deployment and engagement between the two fleets are too well known to be described here, but in the preliminary stages of Jellicoe's masterly resolution of the confused situation an important cruiser engagement occurred. As we have seen, Admiral Hood's three battlecruisers had pushed ahead of the Grand Fleet to improve the liklihood of bringing the High Seas Fleet to action. This was the sort of work the battlecruisers were suited for and Hood thought more like a cruiser admiral than a battle-fleet commander. With the light cruisers *Canterbury* and *Chester* scouting ahead he was hoping to meet Beatty's battlecruisers but because of a dead-reckoning error made by the *Lion* he was much closer to Hipper's ships.

The *Chester* heard gunfire to the southwest and when investigating she ran into Boedicker's 2nd Scouting Group of four light cruisers at a range of little more than three miles. The *Chester* was immediately deluged by a rain of shells without making an effective reply. Showers of shell splinters scythed down her gun crews, although luckily nothing vital was hit and she was able to claw her way clear. Her agony had been exacerbated because

she had been designed for the Greek Navy with a new type of 5.5-inch gun, whose shield did not extend all the way down to the deck as in the Royal Navy's 6-inch. As a result splinters had swept under the shields and three-quarters of the wounds reported were below the knee.

The German cruisers were quickly punished when Hood's battlecruisers came storming out of the mist. The *Wiesbaden* was crippled by 12-inch shells, while the *Pillau* had four boilers put out of action and a fire started in her stokeholds. The survivors of the 2nd Scouting Group fled. Understandably Boedicker concluded that he had run into the main British Fleet and so did Commodore Heinrich, who launched his torpedo boats in an attack. A wild *mêlée* resulted, but again the attack failed and the Germans fell back to regroup.

A second cruiser epic was now about to unfold. The disabled *Wiesbaden* lay between the opposing lines of ships and she was fired on in turn by the British ships as they passed. Still she refused to surrender and her guns fired intermittently. Then Rear-Admiral Arbuthnot's 1st Cruiser Squadron came into view, crossing the bows of the *Lion* in its haste to get at the *Wiesbaden*. Once again the treacherous visibility allowed ships to get surprisingly close and while the cruisers were briskly pouring 9.2-inch shells into the blazing hulk they were surprised by the German battlecruisers and the 3rd Battle Squadron. The *Warrior* was quickly set on fire, but the fate of the *Defence* was the same as the *Indefatigable* and *Queen Mary*; a giant explosion and only a pall of smoke to mark her grave. The *Warrior* might have followed her flagship but for the British ship *Warspite*, whose helm jammed up and was manoeuvring to take up her position astern of the main fleet. Tempted by a brand new battleship rather than a mere cruiser the German ships shifted target and the *Warrior* gratefully limped away.

With the main fleets in action the cruisers could go back to maintaining a watch, but once the German Fleet had finally disengaged, the light forces had to maintain contact once more and provide information. The resulting night action was, if anything, more savage than the day fighting. However, before night fell the *Wiesbaden* scored a final success by torpedoing the British dreadnought *Marlborough* in the engine-room. As the *Wiesbaden* sank with all hands later that night, we will never

Below: Chart of the night action at Jutland showing where the cruisers *Frauenlob, Elbing* and *Black Prince* sank.

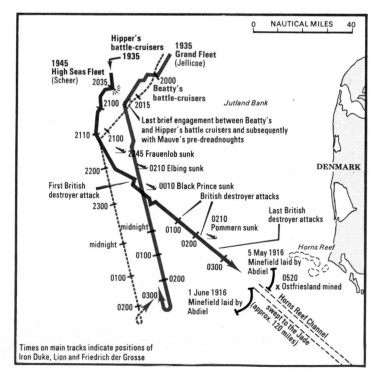

know what heroism it took to get that torpedo tube trained and fired.

In the fading twilight the light cruisers *Castor*, *Calliope*, *Comus* and *Constance* skirmished with the German 3rd Squadron of battleships, but their message to Jellicoe failed to give any details. At 2010 the 3rd Light Cruiser Squadron engaged the 4th Scouting Group and hit the *München*, but soon lost contact without giving any range, course or bearing to the Commander in Chief. The most tantalizing chance of all was presented to the *Caroline* and *Royalist* when at 2045 they sighted three battleships of the German 1st Squadron; just as they turned to attack with torpedoes Vice-Admiral Jerram of the British 2nd Battle Squadron convinced himself that they were British ships and countermanded the attack. The German and British battleships parted without firing a shot.

The situation at the end of this daylight phase was that the two fleets were out of touch but proceeding roughly southward on parallel courses. The British were steaming slightly faster to ensure that they would be between the Germans and their bases at daylight, and had left their light cruisers and destroyers astern to guard against any German attempt to force their way around behind the fleet. Jellicoe was very wary of fighting a night action, for he rightly felt that the risks of friendly ships being attacked far outweighed any possible gain. Given the scattered forces and the primitive communications available in 1916 it was a reasonable conclusion, but the Germans had reached a different one. They had assiduously practiced night fighting and in any case dared not face the Grand Fleet in the morning. It was desperation as much as confidence in his fleet's skill that decided Scheer to risk crossing astern of Jellicoe's main fleet.

He was also aided by luck. At about 2130 the *Lion*, whose signal books had been destroyed in the battle, asked her consort *Princess Royal* to provide the night challenge and reply. This was passed by flashing lamp 'in clear' and was seen by light cruisers of the 2nd and 4th Scouting Groups. Before they turned away they had intercepted the correct challenge, although they had not had time to observe the reply.

Throughout the night engagements which followed British ships held their fire for a fatal few seconds because they were challenged correctly. The first ship to suffer was the light cruiser *Castor*, which was roughly handled by the *Hamburg* and *Elbing* when she mistook them for friendly ships.

Characteristically Goodenough's 2nd Light Cruiser Squadron avoided confusion by correctly interpreting the significance of the gun-flashes of the *Castor* engagement, and they were ready when they met the 4th Scouting Group. The distance came down steadily to 800 yards before the Germans gave their own challenge. Immediately the *Dublin* opened fire and she and the *Southampton* switched on their searchlights. A murderous fight ensued, with both sides firing rapidly and shells bursting everywhere. Shell splinters caused terrible casualties on the *Southampton*'s open deck and both she and the *Dublin* were soon ablaze. The *Nottingham* and *Birmingham* kept their searchlights switched off and pumped shells into the German cruisers without suffering any casualties. So great was the uproar that when a torpedo from the *Southampton* hit the *Frauenlob* nobody on the bridge heard the explosion. Then as if by a miracle the searchlights went out and the firing stopped. The *Frauenlob* broke in two and sank and the rest of her squadron vanished into the night.

The *Southampton* had suffered grievously from splinter damage, with 35 killed and 55 wounded, and her upperworks were riddled with holes. She had been hit 18 times but damage to hull and machinery was superficial. Her sister *Dublin* was hit 13 times but had much lighter casualties. However, with her navigating officer dead and all charts destroyed she lost contact with her squadron during the night.

When the German battleships crashed through the destroyer screen similar scenes were repeated. The armored cruiser *Black Prince*, suddenly blundered into the German battle line and blew up after battleship after battleship had riddled her at point-blank range. In the confusion caused by British destroyers' attacks the light cruiser *Elbing* tried to dodge through the German battle line and failed; she was run down by the battleship *Posen*. The *Rostock* nearly succeeded in the same maneuver, but took a torpedo hit as she slid through between two battleships; she too had to be abandoned.

Jutland (or Skagerrak to the Germans) was tactically indecisive but cruisers on both sides showed that they were much tougher than anyone had claimed. On the other hand, the original British battlecruisers showed only too clearly that they had been cast in the wrong role. Like the *Defence*, on whose design they had been based, the *Invincible* and *Indefatigable* could not hope to engage battleships in a slugging match. On the other hand ships like the *Chester*, *Southampton* and *Wiesbaden* survived very heavy attack. Time and again the light cruisers provided the extra muscle which destroyers lacked, at the same time being small enough to be risked and tough enough to take punishment. Of all the ship types which were tested at Jutland the light cruiser emerged as the most satisfactory, and it is significant that only three were sunk by torpedoes and gunfire, the *Wiesbaden*, *Frauenlob* and *Rostock*.

Above left: The German light cruiser *Pillau* was heavily damaged at Jutland. At the end of the war she was handed over to the Italians as part of the reparations settlement. As the *Bari* she was sunk by Allied air attack in 1943.

Below: The German cruiser *Köln* seen making heavy smoke during her trials in 1917. Especially later in World War I the quality of coal available to the German Navy often made this problem unavoidable.

LESSONS OF JUTLAND

Jutland clearly confirmed the value of the light cruiser as a fleet scout and as stiffener for destroyer attacks. Nothing could be done for the moment about the vulnerability of gun crews to shrapnel and shell splinters, for the 'Town', *Arethusa* and 'C' Classes were all too small for turret mountings, but note was taken for the future. What did improve was fire control and communications.

In June 1917 a platform was installed on the forecastle of HMS *Yarmouth* to test the theory that a Sopwith Pup fighter could be flown from a 20-foot runway. If this proved feasible cruisers could not only launch aircraft to deal with the Zeppelin nuisance but also to investigate suspicious ships. The device was so successful that the Zeppelin threat rapidly disappeared and cruisers found their aircraft more and more useful in the reconnaissance role.

The first flight from a ship had, by coincidence, also taken place from a light cruiser. On 14 November 1910 Eugene B Ely took off from the forecastle of the American scout cruiser USS *Birmingham* in Chesapeake Bay. Ely's epoch-making landing on a ship was also made on a cruiser, the big armored cruiser *Pennsylvania*, two months later. In October 1915 a prototype

catapult was installed on the quarterdeck of the armored cruiser *North Carolina* and in 1917 production models were installed in the *Seattle* and *Huntingdon*. However, they were removed as soon as the US Navy went to war, on the grounds that they would interfere with gunnery.

The German Navy reduced most of its armored cruisers to reserve in 1915–16 to ease the manpower shortage, but in 1917 plans were drawn up to convert the *Roon* to operate seaplanes. The project was dropped but a similar conversion was provided for the light cruiser *Stuttgart*, allowing her to operate three floatplanes.

As mentioned, the Royal Navy made a minimum of alterations to its standard light cruiser design, and from the *Caroline* Class developed a series of 'stretched' variants. There were other cruisers built to meet real or imagined wartime requirements. The most unusual of these were three 'large light cruisers' or small battlecruisers ordered by Lord Fisher in 1915. The original battlecruisers were not all they were claimed to be, but these can only be described as grotesque aberrations. The *Glorious* and *Courageous*, both with 18,000-ton hulls, were given

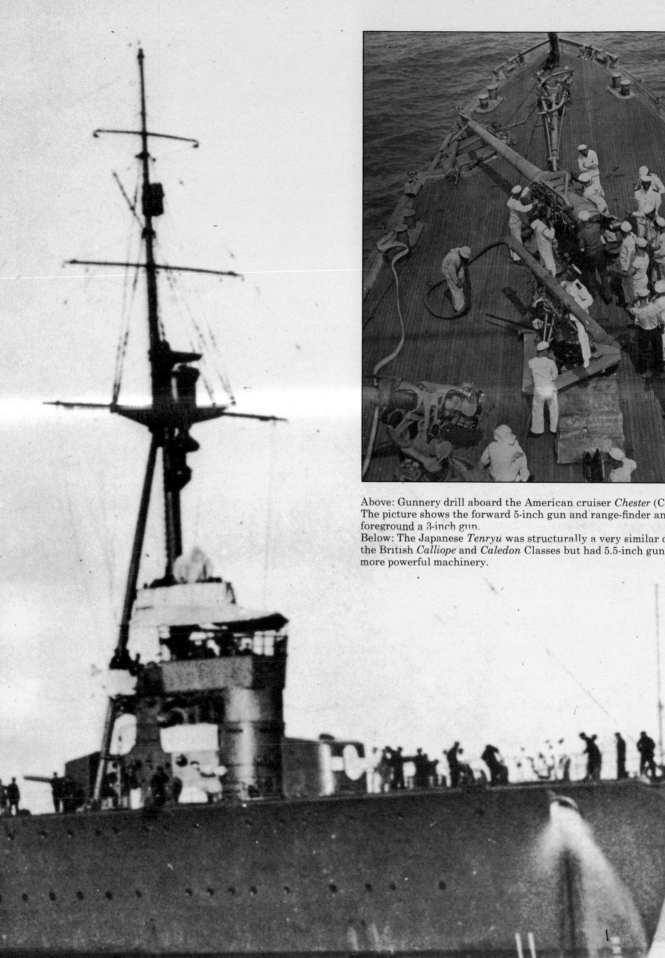

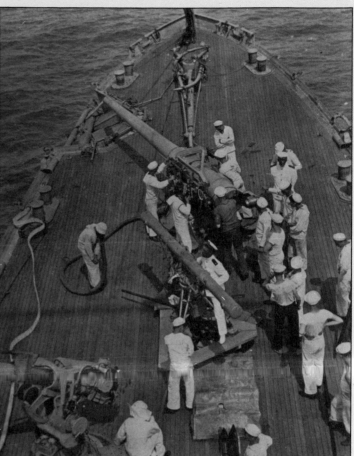

Above: Gunnery drill aboard the American cruiser *Chester* (CL.1). The picture shows the forward 5-inch gun and range-finder and in the foreground a 3-inch gun.
Below: The Japanese *Tenryu* was structurally a very similar design to the British *Calliope* and *Caledon* Classes but had 5.5-inch guns and more powerful machinery.

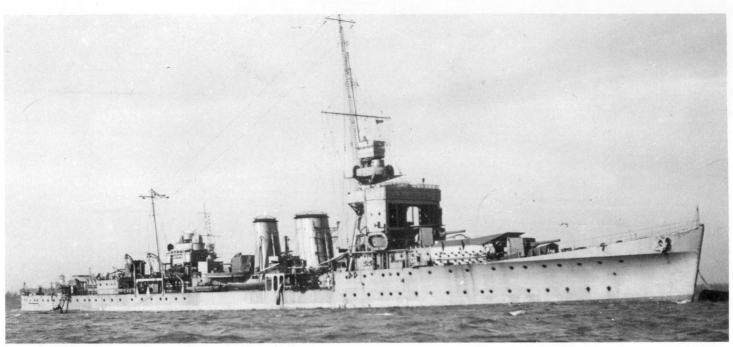

Above: In an effort to accomodate scouting aircraft some British 'C' and 'D' Class ships were built with a combined bridge and hangar. This experiment was not a success.

four 15-inch guns in two turrets, a speed of 31 knots and the same scale of armoring as the *Arethusa*. A third vessel of this type, HMS *Furious*, was to have two single 18-inch guns.

The *Furious* was appropriated for conversion into the Royal Navy's first proper aircraft carrier, but the *Courageous* and *Glorious* joined the Fleet at the end of 1916. The *Courageous* served for a while as a minelayer but when a raid into the Heligoland Bight was planned in late 1917 both were chosen to stiffen the light cruisers and destroyers.

The British force comprised the 1st Cruiser Squadron (*Courageous* and *Glorious*), 1st and 6th Light Cruiser Squadrons (eight ships) with four battlecruisers in support. The intention was to attack the German minesweeping forces keeping channels clear for U-Boats returning from patrol. The British hoped to repeat their success of August 1914, rolling up the patrol line and inflicting casualties on supporting forces if they intervened.

The action began at 0730 on 17 November 1917. Four German light cruisers under Rear-Admiral von Reuter laid heavy smoke-screens while he ordered his forces to fall back but the British ships pressed on through the smokescreens, firing at indistinct targets and hoping that the Germans would lead them through the swept channels in the minefields. Von Reuter was hoping to lure the British into a trap, between his light cruisers and two supporting battleships. These eventually came into action at about 0950 at extreme range.

Rear-Admiral Alexander-Sinclair, flying his flag in the *Cardiff*, ordered his ships to turn about and retire with covering fire from the battlecruiser *Repulse*. As an action it was a disappointment to the British, who missed their last opportunity of bringing major German warships to battle. Despite the heavy fire, both sides' light cruisers came off lightly; the British ships were straddled repeatedly but suffered only seven hits while the Germans took five. The worst damage was suffered by the *Königsberg*, which took considerable damage from a 15-inch shell from HMS *Repulse*. For the British there had been problems of visibility, added to the dangers of the very large minefields in the Heligoland Bight, which reduced the freedom of movement. What the action demonstrated was the uselessness of Fisher's 'large light cruisers' for their 15-inch guns fired so slowly that they could not get ranging salvoes to group around a fast-moving cruiser.

Another class of cruisers started in 1916 was known as the 'Improved *Birmingham*' type or *Hawkins* Class. They were intended to operate on the trade routes with heavy armament, seven single 7.5-inch guns, and a speed of 30 knots. In March 1918, in response to a panic about ultra-fast light cruisers believed to be building in Germany, three more light cruisers were ordered, the *Emerald* Class, with 90 feet more length and 8.5 feet more beam to allow space for double the horsepower of the 'C' and 'D' Classes. The designed speed was 33 knots, although on a displacement of 7600 tons they had the puny armament of seven single 6-inch guns in shields.

This demand for higher speed was undoubtedly influenced by the German minelaying cruisers *Brummer* and *Bremse*. Although only capable of 28 knots at full load, British Intelligence credited them with 35–36 knots, and it was felt that the Royal Navy should have cruisers with some chance of catching them. The fact that these two light cruisers successfully accomplished the destruction of a convoy in 1917 lent some point to the British fears.

The attack took place at daylight on the morning of 17 October 1917 and the victims were a dozen merchantmen (two British, one Belgian, one Danish, five Norwegian and three Swedish), escorted by two destroyers and two armed trawlers. In the misty half-light the two cruisers, which looked similar to the British *Arethusa* Class, managed to close to within 4000 yards before being sighted by HMS *Strongbow*. The confusion caused the destroyer to challenge twice but just as she realized her mistake she was shattered by a salvo of 5.9-inch shells from the *Bremse*, now closing to little more than a mile. With her radio destroyed she could not warn her consort astern, the convoy or the distant escorts and was left helpless and sinking.

The *Mary Rose* had been alerted by the flash and sound of gunfire ahead but she too was smothered by accurate salvoes, this time from the *Brummer*, and was hit almost as soon as she challenged. She sank quickly and the cruisers turned to finish off the *Strongbow* and the convoy at their leisure. Two hours later 10 of the merchant ships had been sunk and some 40 neutral seamen and 135 British were dead. It was a classic example of cruisers used intelligently, and it was to remain uppermost in the minds of the admirals who planned Hitler's new navy 15 years later.

The dominance of the British light cruisers over their German counterparts did not go unnoticed in the United States. In 1916, as part of a massive augmentation of the US Navy, Congress authorized the first of a dozen 'scout cruisers.' These were the first modern light cruisers built for the US Navy in 12 years.

The class which resulted did not materialize until 1923–25 but even when first drawn up the design was so antiquated as to be quaint. On paper they outclassed all other cruisers, with a speed of 35 knots, but the eight 6-inch guns were disposed in old fashioned double-storeyed casemates on the broadside. Nor was the torpedo armament impressive; at a time when the British were planning to give the 'D' Class four triple 21-inch mountings, the American cruisers had only two twin sets. Before the *Omaha* was laid down in 1918 the Bureau of Ships bowed to criticism by adding two twin 6-inch gun mountings and two triple torpedo tubes. However the guns were only in light splinterproof shields and the rise of displacement could only be limited by reducing the armor to a small patch at the water line over the machinery spaces. Thus at a designed displacement of 7500 tons they were more poorly protected and slower than originally planned. The most impressive feature of the *Omaha* Class was their speed. With 90,000 shaft horsepower they all made 33–34 knots on trials but this was achieved at light displacement; at load draught they displaced over 9000 tons, making such speeds impossible.

The *Omaha* design naturally provoked a Japanese reply. Only two cruisers had been built during the war, the 3500-ton *Tatsuta* and *Tenryu*, but in 1918–19 five of an expanded type, the *Kuma* Class, were laid down. They had seven 5.5-inch guns and displaced 5500 tons. They and the six very similar *Natori* Class had the same installed power as the *Omaha* Class but being lighter ships they found it easier to reach their designed speed of 33 knots.

The *Tatsuta* and *Tenryu* had been intended principally as destroyer leaders. In contrast the next class was designated as 'scouts' and was intended to displace 7200 tons. News of the US *Omaha* Class forced a change of mind and new plans were drawn up for eight 5500-tonners. The idea was to match the eight-gunned *Omaha* with seven 5.5-inch guns disposed more sensibly to give a heavier broadside but the Americans' decision to upgun the *Omaha* with twin center-line guns nullified this advantage. The next step was to be much more ingenious and will be covered in the next chapter.

The experiences of the war, particularly in the North Sea, had done much to restore the cruiser's reputation. Appropriately enough, a cruiser played a dramatic role in the last act of the

Above: The Japanese light cruiser *Sendai* seen with an aircraft catapult fitted aft. The *Sendai* entered service in 1925 and was sunk in November 1943 at Empress Augusta Bay.

naval war. When on 21 November 1918 the German High Seas Fleet steamed across the North Sea to surrender to the Allies, it was a small light cruiser HMS *Cardiff* which led the mighty dreadnoughts into the Firth of Forth. It was meant to humiliate the Germans but the gesture inadvertently paid a well-deserved compliment to the enormous burden shouldered by cruisers in the war.

Below: The USS *Birmingham* seen in Brest in October 1918. The *Birmingham* had served on escort duty in the Atlantic.

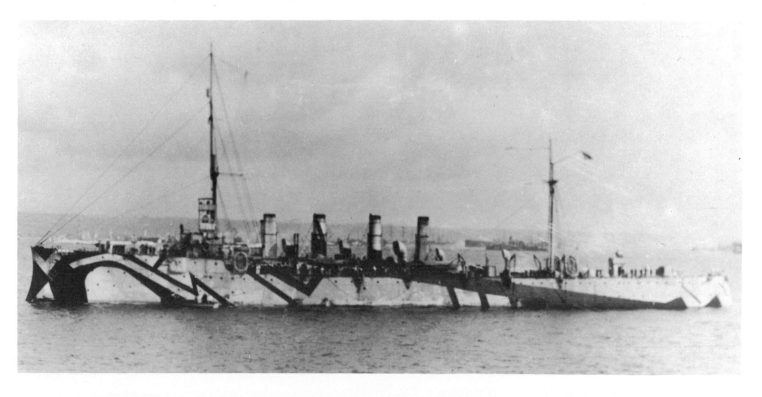

TREATY LIMITATIO IMPOSED

The cruiser had started the war under something of a cloud but it finished the war with a greatly enhanced reputation, whereas the battlecruiser was now rightly regarded with suspicion. The battleship, moreover, was costly and more vulnerable to torpedoes and mines than had been thought. After the Armistice many navies looked to cruisers with renewed interest as the most cost-effective fighting ships.

The US Navy began to plan in 1919 for an entirely new strategy. Hitherto it was the eastern seaboard that had to be safeguarded against an ill-defined but sincerely felt threat from Great Britain, but from 1919 the expanding Japanese Empire was a much more certain threat in the Pacific. The *Omaha* Class were patently unsuited to long-range operations in the Pacific and new designs were needed, with more endurance and gunpower. The Bureau of Ordnance was investigating a new 8-inch gun and if this was to be adopted it would need a heavier mounting, and therefore a much bigger ship than the 7000-ton *Omaha*.

The Bureau of Construction and Repair began work on two parallel series of cruiser designs in 1919. The main weakness of these designs was the requirement for excessive speed, for it meant unarmored gun mountings and at best a meager scale of protection. This was to be a recurring theme in discussions on cruisers: high speed in a seaway and large fuel stowage inevitably meant a bigger and more expensive cruiser, with a big crew and higher operating costs.

The Japanese were keeping a wary eye on the Americans and as early as 1918 had drafted rough designs for an 8000-ton scout cruiser, armed with five or six twin 5.5-inch or four twin 8-inch, and a speed of 35.5 knots. The design was at such an undefined stage that although the Cabinet Council authorized the building of one per year for four years, the Navy asked for them to be deferred. The American decision in 1920 to increase the *Omaha*'s armament to 12 guns was one reason and the visit of HMS *Hawkins* to Japan was another. The Japanese were very impressed by the British cruiser, particularly because of her weight of broadside. The 5500-ton *Kuma*'s broadside of six 5.5-inch delivered 228kg of shells against 544kg from the *Hawkins*.

The upshot was that the Japanese decided to adopt the 8-inch gun, drawing up plans for a 7500-ton ship armed with three twin mountings and capable of 35 knots. To save weight they adopted the same solution as in the British *Arethusa*; the armor protection worked longitudinally as part of the hull. A further innovation was to keep the longitudinal strength-members continuous, even if it resulted in an undulating deck-line.

In July 1921 the US President invited the Japanese, British, French and Italians to discuss ways of limiting their naval strength to avoid the sort of costly arms race which had led to

ONS

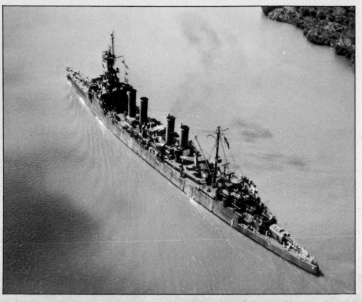

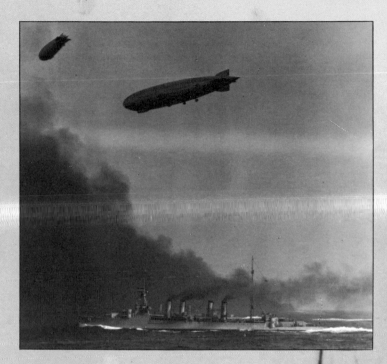

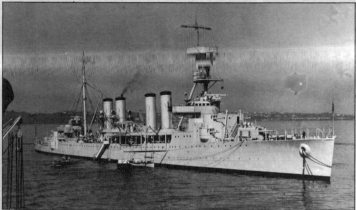

Above: The *Trenton* (CL.11) seen in the early 1930s.
Above left: The *Raleigh* is overshadowed by the dirigible *Los Angeles* and a blimp during maneuvers in 1930.
Top: The *Richmond* (CL.9) near the end of her long career, seen in Gatun Lake, Panama Canal in October 1945.
Below: The *Richmond* works up to full speed during builders' trials in May 1923. The uncluttered trials rig can be compared with the additional equipment found necessary in World War II as shown in the 1945 picture at top.

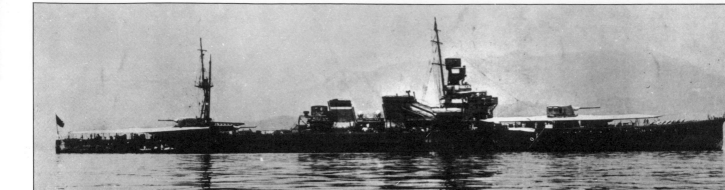

war in 1914. The major provisions of the resulting Washington Treaty were concerned with battleships, but the American delegation skilfully fought for the right to build the big 8-inch gunned cruisers that they had planned. The treaty created two classes of cruiser, 'heavy' cruisers of no more than 10,000 tons and 8-inch guns, and 'light' cruisers armed with lighter guns. Although numbers of heavy cruisers were fixed in the same ratio as capital ships, light cruisers were not limited in number.

The Japanese were in the most difficult position of all. Since it was obvious that the United States was hostile to any renewal of the Anglo-Japanese Treaty, they were faced with the possibility of war with one or both navies, but without knowledge of the latest technical developments. The Japanese decided to embark on a course, not of slavish copying as so many people still believe, but of almost reckless, innovation.

Late in 1917 approval had been given for an experimental small cruiser, but work did not start until 1921, when the order was given for a cruiser displacing only 2890 tons, armed with six 5.5-inch guns, four torpedo tubes and with a speed of 35.5 knots. The published standard tonnage of the *Yubari* was 2890 tons, whereas the ship actually displaced 17 percent more. Puzzled Western naval intelligence departments wrestled unsuccessfully with the *Yubari*'s staggering figures.

Nonetheless the *Yubari* was an ingenious design. On trials she showed no sign of hull weakness and reached 34.8 knots on a displacement of 3309 tons, a loss of only 0.7 knots in spite of being overweight. Another improvement was to give her twin 61cm (24-inch) torpedo tubes instead of the 53cm (21-inch) tubes in earlier cruisers. The extra volume gave greater range and destructive power than any comparable torpedo.

Profiting by the experience gained the Technical Department went on to design a much bigger cruiser, capable of matching not only the American *Omaha* Class but also the British *Hawkins* Class. It was in its way as startling a design as the *Yubari*, with six 20cm (7.4-inch) guns, 3-inch side armor and a speed of 34.5 knots, all on a standard displacement of 7100 tons. It was thus well within the limit eventually imposed by the Washington Treaty. The order was placed on 20 June 1922, only four months after the signature of the Treaty.

As in the *Yubari* armor was worked in longitudinally, without plating behind it. In spite of all precautions taken in supervising weights the displacement rose by nearly 1000 tons during construction, as a result of errors in the calculations. In practice the *Kako* worked out at 9540 tonnes and her sister *Furutaka* at 9544 tonnes in the 2/3 trials condition. Fortunately the designer had insisted on a good metacentric height to limit the angle of the heel if the ship should be partially flooded. This, combined with the fact that topweight had been kept down, meant that the ships did not suffer unduly from the increased displacement. On trials both ships were extremely fast, making their designed speed of 34.5 knots.

The first US Navy cruisers built after the treaty make an interesting contrast with the *Furutaka*. The designers decided

against trying to protect the ship against 8-inch shell fire, opting for protection against hits from 6-inch shell and destroyers' guns. What emerged was a ship displacing 9100 tons in standard condition, armed with ten 8-inch guns and capable of 32.5 knots. In comparison with the Japanese ships the *Salt Lake City* and *Pensacola* traded speed for gunpower and endurance, for they were designed to steam 10,000 miles at 15 knots. They also struck an unusual note in having the triple turrets superimposed above the twin turrets.

The British response was quite different. The war had confirmed the need for freeboard in rough weather operations, the gunnery experts favored four twin gun-mountings, and tactical considerations dictated a speed of 33 knots to match the Japanese and American ships. However, by July 1923 preliminary calculations showed that a ship with these characteristics might have as little as 820 tons of armor out of the total 10,000 tons.

Above left: The Japanese heavy cruiser *Kako*, sister ship of the *Furutaka*.
Below: The Italian heavy cruiser *Gorizia* runs her trials in 1931 without her 8-inch gun turret fitted.

The Director of Naval Construction proposed to abandon side armor altogether, only protecting the magazines and ammunition hoists against 8-inch shell fire out to 20,000 yards. However the Admiralty Board subsequently dropped its requirement for 33 knots and this allowed a further 400 tons of armor.

Seven ships were laid down in 1924–25, including two for the Royal Australian Navy. The five British ships were given county names in honor of the old *Kent* Class of 1901, while the Australian ships were named HMAS *Australia* and HMAS *Canberra*. When the first ship, HMS *Berwick* appeared at the end of 1927 she was not greeted with any enthusiasm. Her high freeboard and three funnels seemed more appropriate to an ocean liner, especially when compared with the sleek lines of the *Furutaka*.

In April 1922 the French Chamber of Deputies voted funds for the first cruisers built in more than 15 years. The three 7000-ton *Duguay Trouin* Class carried four twin 6.1-inch (155mm) gun-mountings and made 33 knots on trials, but at the cost of having virtually no protection. In 1924 funds were voted for two heavy cruisers. The *Duquesne* and *Tourville* were little more than 8-inch gunned versions of the light cruisers, with only 430 tons of armor and a speed of 33.75 knots.

It was left to the Italians to complete the Washington cycle. In 1925 two heavy cruisers were begun, the *Trento* and *Trieste*. In keeping with an Italian policy of building fast ships they were designed for 35 knots, but with only a shallow water-line belt and a partial deck. To make matters worse the Italians had developed the habit of running trials under unrealistic conditions, without ammunition or gun mountings installed. It meant that the sea speed in full load condition was much lower. The *Trento* made 35.6 knots on an eight-hour trial but could count on only 30 knots when fully loaded.

TREATY LIMITATIC
AVOIDED

Nobody was satisfied with the first generation of heavy cruisers produced after the Washington Treaty. All were a disappointment, either too big and costly or much heavier than intended. It was hardly surprising, therefore, to see a series of improved versions appearing very soon afterwards.

The Japanese followed the *Furutaka* with two very similar ships, *Aoba* and *Kinugasa*, but with several improvements. Three twin 8-inch turrets were fitted instead of the six singles, while the antiaircraft armament was increased. As the standard displacement rose by only 200 tons they had no difficulty in reaching 34 knots. Even so, like the *Furutaka* they were cramped, wet and lightly armored.

The US Navy did not like the *Salt Lake City* Class, regarding them as deficient in seaworthiness and overgunned at the expense of protection. The next ships, the six *Northamptons* were given a raised forecastle to improve seakeeping and had a more rational arrangement of guns. Three triple turrets saved weight and reduced the area to be protected, while the weight saved was used to provide hangars amidships for the floatplanes. The US Navy was the first to appreciate the vulnerability of aircraft to weather damage and other navies eventually followed its example.

The British also looked at their *Kent* design, being concerned to improve speed and protection and provide a floatplane and catapult. Not much could be done to the scale of protection but some detailed improvements were made. In other respects the four *London* Class looked very much the same as the *Kents*. Four more ships were planned, but they were given a different 8-inch turret and further minor improvements to protection. The *Dorsetshire* and *Norfolk* joined the Fleet in 1930 but the *Northumberland* and *Surrey* were suspended in 1928 and cancelled in 1930.

Impressed by the *Furutaka* design and conscious of the need to keep up numbers of cruisers, the Admiralty graded the 'Counties' as A Class ships and called for designs for a smaller B Class type, of 8000 tons and with six 8-inch guns. Only the *Exeter* and *York* were built, and they showed considerable improvements. The shorter hull could be given 3-inch water-line armor, and higher speed was also possible. There was some reduction in freeboard but not sufficient to reduce seaworthiness. However in spite of achieving all this on a standard displacement of 8390 tons (*Exeter*) the B Class were unfavorably compared with the Japanese ships. It was alleged that the *Furutaka* Class could match them in protection and speed on only 7100 tons, whereas in fact there was little real difference in tonnage, and the *Furutaka* carried some 300 tons less fuel.

The French had intended to build more of the *Duquesne* Class but instead recast the design to remedy some of the deficiencies. The weight of armor was increased in all four ships, partly by redesigning machinery. The last of the four, the *Dupleix*, had 1553 tons of armor, as against 430 tons in the *Duquesne*.

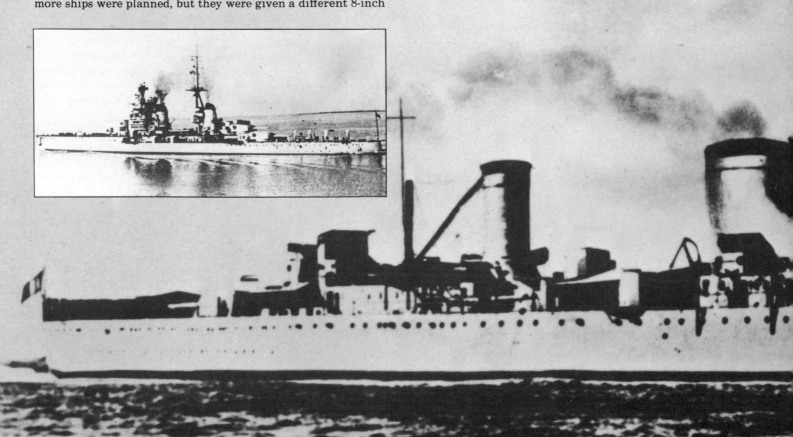

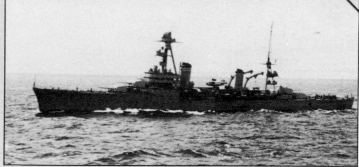

The Italians were particularly worried about the weaknesses of their *Trento* Class. The building of 15,000-ton cruisers was considered, but as this was forbidden by treaty a slower but better-armored version of the *Trento* was chosen. She was to have a sea speed of 32 knots, 200mm (7.9-inch) armor and eight 8-inch guns.

Even the most ingenious Italian ship designers could not reconcile such requirements on a standard displacement of 10,000 tons, and it was soon clear that the armor had to be thinned. Even so with 150mm (5.9-inch) armor amidships the standard displacement worked out at 11,500 tons. By concealing the fact that the new ships were 15 percent over the Treaty limit the Italian Navy established a new fashion for outright cheating. Four of the class, the *Fiume*, *Zara*, *Gorizia* and *Pola* were built followed by a third *Trento* type, named *Bolzano*.

Even with a 15 percent margin over the Treaty limit it was a remarkable achievement to combine such heavy armor with speed. All four reached their designed speed of 32 knots, *Zara* being the fastest at 35.2 knots on 10,776 tons without gun turrets on board. At standard displacement they were good for about 33 knots but sea speed in load condition fell to 29 knots.

The Japanese now found themselves outclassed by the new 10,000-ton cruisers. They conformed to their doctrine of building ships equal or superior to all contemporaries and expanded the *Kinugasa* design to enable two more twin 8-inch gun-mountings to be incorporated and another inch of side armor. However the design worked out at 10,940 tons at standard displacement; the 2/3 trial displacement was 12,374 tons and there was no margin of stability. Nonetheless the four *Ashigara* Class made a great impression.

The Naval Staff liked the *Ashigara* design, so for an improved design the constructors were forbidden to make any reduction in fighting qualities to comply with the Washington Treaty. As a result the four *Takao* Class displaced 11,350 tons in standard condition. The scale of armoring was generally as in the *Ashigara* but 5-inch plating was provided for the magazines.

The American answer to those eight powerful ships was the *San Francisco* Class. The forecastle was lengthened to improve seakeeping and the water-line armor extended to take in the forward 8-inch turrets. There was no attempt to match the Japanese ships' speed but they were capable of 32.75 knots and had good endurance. In many ways they were the most balanced of the later Washington cruisers and all seven gave sterling service in World War II.

The signatories to the original Washington Treaty were well aware that they had inadvertently committed themselves to building very costly ships. The British were particularly keen to get away from the 10,000-ton 8-inch gunned cruiser and at the London Naval Conference in 1930 they were able to have a new treaty accepted dividing cruisers into Type A, armed with guns of greater than 6.1-inch caliber (allowing for the French light cruisers) but not exceeding 8-inch, and Type B, with guns of 6.1-inch caliber or less. The treaty also laid down an age limit for

Far left: The Italian heavy cruiser *Zara* was armed with eight 8-inch and twelve 3.9-inch guns.
Top: The *Suffren* was one of the four French ships built incorporating improvements from the *Duquesne* Class but was still too lightly protected.
Below: The *Alberto di Guissano* and her sisters of the 'Condottieri' type made astonishing speeds of up to 42 knots on trials but could only make 30 knots fully loaded.

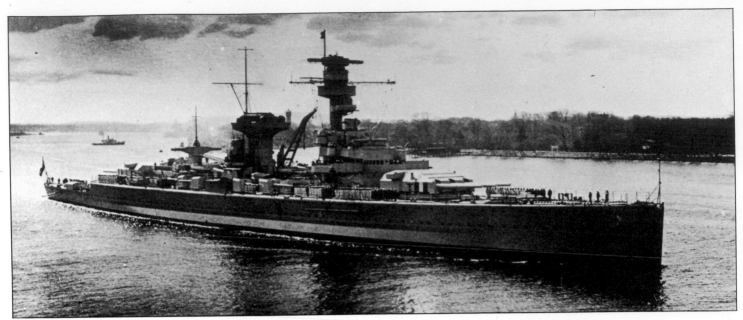

Above: The 'panzerschiff Deutschland pictured in 1937. The recognition marks used by neutral warships during the Spanish Civil War can be seen on the forward turret.

the replacement of cruisers as well as tonnage totals for each navy. France and Italy refused to accept tonnage limitations, a hollow gesture since neither had the resources to outbuild Britain, the United States and Japan.

Up to now the arguments over cruisers affected only the five front-rank navies, with Britain, Japan and the United States all very much concerned with what the other two were doing, and France and Italy mainly watching one another. However almost imperceptibly Germany had edged back into the cruiser game, and her efforts were to cause much disruption and dissent.

Under the Treaty of Versailles Germany was permitted to retain eight very elderly protected cruisers. New construction was permitted to replace these cruisers in due course but they were not to exceed 6000 tons. There was no question of heavy cruisers, the only other large ships permitted being 10,000 ton ships with 11-inch guns, intended as replacements for six predreadnought battleships.

Work started almost immediately on the design of a new light

cruiser intended for training and known first simply as *Kreuzer A* but launched as the *Emden*. She showed little improvement over the *Köln* Class built in 1915–18, with eight single guns of an older pattern, four winged out amidships and four on the center line forward and aft. Speed was only 29 knots and armoring was on a light scale but she provided valuable experience after a comparatively long gap in construction.

Under the 1925–26 Program three more-powerful light cruisers were planned, named *Königsberg*, *Karlsruhe* and *Köln*. The attempt to provide a balanced design on such a limited displacement was not successful; they crammed three triple 15cm mountings and four triple torpedo tubes into the narrow hull. Endurance was only 5200 miles at 19 knots, which made them useless for operating on the high seas. At 6650 tons in standard condition they were 10 percent overweight and they were poor bargains in spite of the technical ingenuity of the design.

These faults were tackled in the next cruiser, the *Leipzig*. With another 3 feet on the beam she was more weatherly, and the machinery was also improved. However, armoring and endurance were still low and standard displacement rose to 6710 tons.

In 1929 work started on the first replacement for the old battle-

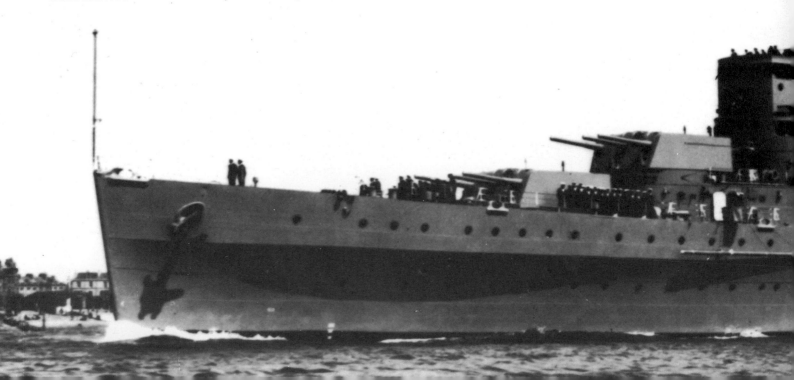

ships. The Versailles Treaty had been deliberately framed to prohibit anything but a coast defense ship. Pains had been taken to exclude anything resembling the old armored cruiser, fast enough to run away from battleships and powerful enough to sink any light cruiser. Yet this was exactly what the German designers strove to achieve. On a nominal standard displacement of 10,000 tons (actually 11,700 tons) they mounted two triple 11-inch (28cm) gun turrets and by adopting an all-diesel power plant they could provide a staggering 10,000 miles endurance. Although the speed was only 26 knots and the armor no thicker than the best-protected heavy cruisers, the overall combination seemed ideal for a commerce-raider.

The name chosen for the ship, *Deutschland*, epitomized her importance to the German nation. By evading the restrictions of what was regarded as a vicious attempt to shackle Germany forever, she had shown that German genius and will could still triumph. Nor were foreigners slow to realize her importance. Dubbed a 'pocket-battleship' by the British press, it was claimed that the only ships capable both of catching and destroying her were the British and Japanese battlecruisers.

Two more *panzerschiff* were built, the *Admiral Scheer* and *Admiral Graf Spee* but a further three were cancelled since their shortcomings had now become obvious to the German Navy if

Below: The British cruiser *Southampton* carried twelve 6-inch guns. She was sunk in the Mediterranean in 1941.

not to anyone else. To meet them the French accelerated design work on a proposed *croiseur de combat*, while the British, Italians and Americans began to plan for 30-knot battleships. The British were particularly worried and began to consider what tactics should be used to counter ships of the *Deutschland* type.

The newly renamed *Kriegsmarine* rapidly set about building a fleet and in 1933 a further light cruiser was authorized, followed by two heavy cruisers the next year. The light cruiser *Nürnberg* was an improvement on the *Leipzig* but the *Admiral Hipper* and *Blücher* were much more formidable ships. Taking even more liberties with the 10,000 ton limit than any other Navy, they displaced 13,900 tons and so had a reasonable scale of protection and heavy armament; four twin 8-inch guns and a heavy anti-aircraft battery. Unfortunately they failed in the most important area of propulsion. The high pressure steam plant was not reliable and the 6800-mile endurance was poor.

The French reply to the *panzerschiff* was impressive but expensive. The particulars of the *croiseur de combat* were modified until a 26,500-ton battlecruiser emerged instead, armed with two quadruple 13-inch (330mm) gun mountings, steaming at nearly 30 knots but protected only by 9-inch side armor.

A more cost-effective solution to the problem was the heavy cruiser *Algerie*, completed in 1934. A balanced design, she was the most impressive of all the European Treaty cruisers with good endurance, 8700 miles at 15 knots. She was the only European 8-inch cruiser to bear comparison with the designs produced in the United States and Japan.

In 1931, with a full quota of 12 heavy cruisers, the Imperial Japanese Navy turned to a new type of powerful light cruiser, well protected and carrying sufficient 6-inch guns to pose a serious threat to most 8-inch cruisers. The *Mogami* Class ships were designed with five triple 6.1-inch gun turrets disposed as in the *Takao* Class and with similar protection and speed. This was asking a lot of only 10,000 tons but it was hoped that weight could be saved by the extensive use of light alloy in the super-structure and electric welding. As far as the outside world was

concerned the new cruisers had a standard displacement of only 8500 tons.

This time the Japanese had overreached themselves, and the first two ships, *Mogami* and *Mikuma*, ran into severe problems on their trials in the summer of 1935. During firing trials the welded seams started to open from the shocks transmitted through the hull. Then difficulties were encountered in training the main gun turrets, and it was found that the weight of the turrets and training machinery was deforming the hull. To cap everything the heavy antiaircraft armament (four twin 5-inch guns) contributed to a massive excess of topweight, making the ships unstable.

The *Mikuma* and *Mogami* were hurriedly put into reserve while the design was reexamined. By removing the after pair of 5-inch AA guns and the two aircraft catapults it was possible to reduce topweight, but it also proved necessary to add external bulges to the hull to improve stability. By the time the alterations were finished the displacement had risen to 11,200 tons and speed was reduced from 37 to 35 knots.

The US Navy was quick to see the advantage of the big light cruiser, for in bad visibility or night actions the 6-inch guns could bring a greater volume of fire to bear. It was the old argument for smothering fire and without radar to assist long-range gunnery there was considerable validity in it. In January 1935 the first of the nine *Brooklyn* Class light cruisers was laid down, carrying fifteen 6-inch guns in the same disposition as the *Mogami*. They were similar to the *San Francisco* Class in looks but with the aircraft hangar built over the square stern. Four aircraft were usually embarked.

The Royal Navy was permitted to build 91,000 tons of cruisers, and this had resulted in a program for 14 light cruisers of 6500 tons, the *Leander* Class, armed with four twin 6-inch mountings and capable of steaming 12,000 miles. Ultimately the design worked out at 7100 tons, which meant building only nine ships, the balance being taken up with the six smaller *Arethusa* Class of 5250 tons with six 6-inch guns. Protection was slightly thinner but AA armament remained the same and they also had 12,000 miles endurance. They were a sound answer to a knotty problem, for in the long run numbers of cruisers were more important to the British than individual quality.

The news of the *Mogami* Class upset these calculations, however, and the Admiralty reluctantly decided to build two 9100-ton cruisers with twelve 6-inch guns. This meant that the *Leander*s were cut to eight and the *Arethusa*s to four. The design had triple 6-inch turrets replacing the twins for the first time, protection scaled up and hangars provided for the catapult floatplanes. Unlike the Americans and Japanese the designers felt that a fifth turret with its limited arcs of fire was hardly worth the weight. The two ships were launched as the *Southampton* and *Newcastle* in 1936.

The Washington and London Naval Treaties expired in 1936, and Japan had already given the required two years' notice of her withdrawal from their provisions. The treaty of 1936 was no more constructive than its predecessors. All limitations on numbers were scrapped but the signatories agreed to exchange information on their building programs. No more Type A cruisers were to be built until 1943 and a new limit of 8000 tons was imposed on Type B cruisers but there were 'escalator' clauses to permit the signatories to exceed the limits if any nation was increasing its strength in specific categories. For the British it meant that they could get on with the cruisers which they needed, rather than worrying about tonnage totals. At the end of 1934 another two of the *Southampton* type were laid down, followed by four in 1935.

The sands were running out fast and it was evident to all but the most starry-eyed pacifist that Europe would probably be at war within three or four years. The Admiralty ordered two enlarged *Southamptons* in 1936, armored to withstand 8-inch shell fire. Although nominally still 10,000 tons the *Belfast* and *Edinburgh* had an actual standard displacement of 10,550 tons and were among the most powerful cruisers afloat. The good characteristics of the *Southampton* Class were maintained within the 8000-ton limit in the 'Colony' or *Fiji* Class ordered in 1937. They retained the twelve 6-inch guns and had a more effective distribution of the armor, all for a slight decrease in speed.

There was also the problem of what to do with the old light cruisers from the previous war. The *Hawkins* Class was supposed to be scrapped to comply with the 1930 Treaty and the 'C' and 'D' Classes were now too small for front-line duties. In 1935 experimental modernization had been carried out on the *Coventry* and *Curlew*, with their 6-inch guns replaced by single 4-inch antiaircraft guns for use in the Mediterranean as AA escorts. They proved a great success, and in 1938–39 four were taken in hand for more modern rearmament. At the same time a new type of light cruiser was under consideration for the big rearmament program which was to begin in 1937.

It was decided from the outset that the new small cruisers should be antiaircraft ships. A new dual-purpose twin 5.25-inch gun was the obvious choice for the new ships. They were given

five of these mountings, three forward superimposed over one another and another two aft, with close-range light guns amidships. The new ships became the *Dido* Class and 16 were ordered by 1939.

The French, like the British, were anxious to get away from the expensive heavy cruiser, and after the *Algerie*, built no more of the type. Instead they turned successfully to fast light cruisers of 6700 tons to match the Italians' speed. In 1931 the cruiser-minelayer *Emile Bertin* was laid down, with nine 6-inch guns on a displacement of less than 6000 tons. She was a great success, making an average of 36.73 knots for eight hours and nearly 40 knots maximum. This was ideal for a getaway after laying mines, but apart from some flimsy side plating and a thin deck she was unprotected and had little endurance. The next class was based on the *Emile Bertin* but without her faults. On a standard displacement of 7600 tons the *La Galissonière* Class had the same armament but nearly 20 percent less power to permit good protection. Even so, on trials they made 32.5 knots easily and in light condition reached 35 knots.

Looking back on the Washington Treaty and the subsequent international agreements it can be seen how vain were the hopes of statesmen that they could force navies to build only certain types of cruisers. The prevailing obsession became one of matching individual cruisers in other navies. Yet experience had always shown that matched opponents were unlikely to meet in battle. The antidote to such ships as the *Mogami* or the *Deutschland* was to concentrate a number of smaller ships. Ironically in 1939 all four *Mogamis* went into dock for reconstruction and when they emerged the triple 6.1-inch guns had been replaced by twin 8-inch – at a stroke the Japanese had added four heavy cruisers to their strength and the rationale for the *Brooklyn* and *Southampton* Classes had vanished.

On the other hand there can be no doubt that the attention paid to cruiser design in the 1920s and 1930s did much to further research into new ways of weight-saving and better machinery. However it had been expensive, and much creative effort had been devoted for little result. After nearly two decades most navies had finally accepted that smaller cruisers were a better bargain than big ones.

As well as their fifteen 6-inch guns the *Brooklyn* Class carried eight 5-inch. They could make 32 knots.

CONVOYS AND COMMERCE-RAID

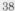

The German Navy, for all its progress since 1933 and the Anglo-German Naval Treaty of 1935, was not well placed to fight the Royal Navy. The third heavy cruiser, the *Prinz Eugen*, was not yet ready and her later sisters *Lützow* and *Seydlitz* were a long way away from completion. The *Lützow* was sold to the Soviet Union in 1940, while neither the *Seydlitz* nor the light cruisers authorized under the 1938 and 1939 programs were ever completed.

As the main effort of the German surface fleet was to be against British trade it was essential that ships be at sea before any sort of blockade could be formed. On 21 August 1939 the *Admiral Graf Spee* left Germany for the North Atlantic, followed three days later by her sister *Deutschland* each accompanied by a supply ship carrying fuel and provisions. Neither ship was

spotted, although a few days after the outbreak of war the *Graf Spee* had a lucky escape from detection when her floatplane sighted the heavy cruiser *Cumberland* only 30 miles away. The *panzerschiff* was able to break away undetected but inevitably her presence in the South Atlantic was revealed when she began to sink isolated merchant ships. As soon as the reports were confirmed the British and French set up eight hunting groups, six of them including cruisers.

As reports of sinkings continued to come in from the South Atlantic the Admiralty sifted them to try to predict the next move. As always the temptation was to spread ships around but the Admiralty wisely ordered Commodore Harwood, commanding Force G, to keep his force concentrated. He chose to cover the focal area around the River Plate reasoning that the con-

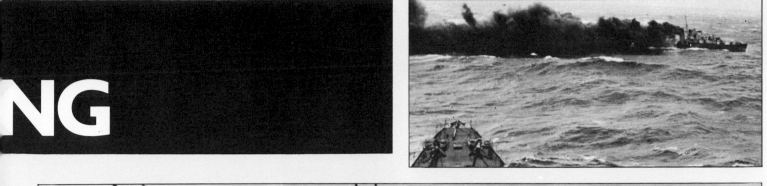

NG

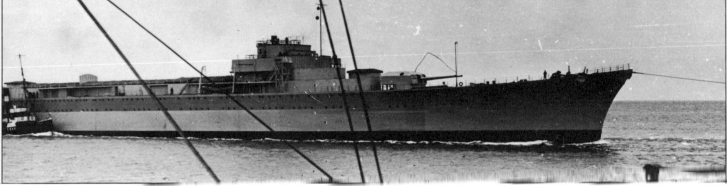

Above: As part of the Nazi-Soviet agreement of 1939 Hitler gave Stalin the incomplete heavy cruiser *Lützow* seen here leaving for Leningrad in 1940.
Top: The destroyer *Glowworm* falls to the guns of the *Hipper*.
Below: The light cruiser *Köln* lies at anchor in Kiel in 1936. The torpedo boat *Seeadler* passes by in the foreground.

40

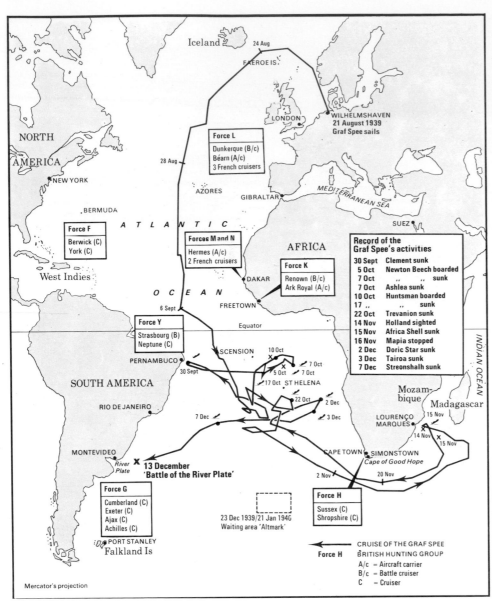

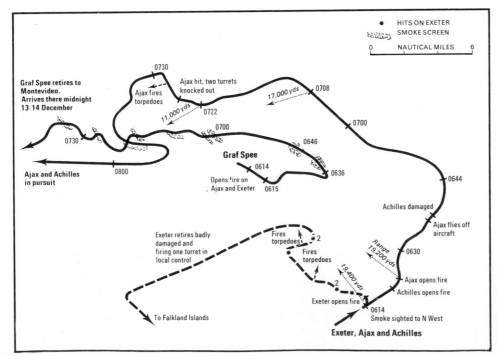

Map annotations:

Force L
Dunkerque (B/c)
Béarn (A/c)
3 French cruisers

Force F
Berwick (C)
York (C)

Forces M and N
Hermes (A/c)
2 French cruisers

Force K
Renown (B/c)
Ark Royal (A/c)

Record of the Graf Spee's activities
30 Sept Clement sunk
5 Oct Newton Beech boarded
7 Oct „ „ sunk
7 Oct Ashlea sunk
10 Oct Huntsman boarded
17 „ „ sunk
22 Oct Trevanion sunk
14 Nov Holland sighted
15 Nov Africa Shell sunk
16 Nov Mapia stopped
2 Dec Doric Star sunk
3 Dec Tairoa sunk
7 Dec Streonshalh sunk

Force Y
Strasbourg (B)
Neptune (C)

Force H
Sussex (C)
Shropshire (C)

Force G
Cumberland (C)
Exeter (C)
Ajax (C)
Achilles (C)

13 December 'Battle of the River Plate'

23 Dec 1939/21 Jan 1940 Waiting area 'Altmark'

CRUISE OF THE GRAF SPEE
Force H BRITISH HUNTING GROUP
A/c = Aircraft carrier
B/c = Battle cruiser
C = Cruiser

Mercator's projection

Lower map annotations:

HITS ON EXETER
SMOKE SCREEN
0 NAUTICAL MILES 6

Graf Spee retires to Montevideo. Arrives there midnight 13/14 December

Ajax hit, two turrets knocked out

Ajax fires torpedoes

0730 / 0708 / 0722 / 0700 / 17,000 yds / 11,000 yds

Ajax and Achilles in pursuit 0800 / 0730

Graf Spee Opens fire on Ajax and Exeter 0614 / 0615 / 0636 / 0646 / 0700 / 0644

Exeter retires badly damaged and firing one turret in local control

Fires torpedoes / 2

Achilles damaged
Ajax flies off aircraft
Range 19,200 yds 0630
Ajax opens fire
Achilles opens fire
19,400 yds

Exeter opens fire 0614 Smoke sighted to N West

To Falkland Islands

Exeter, Ajax and Achilles

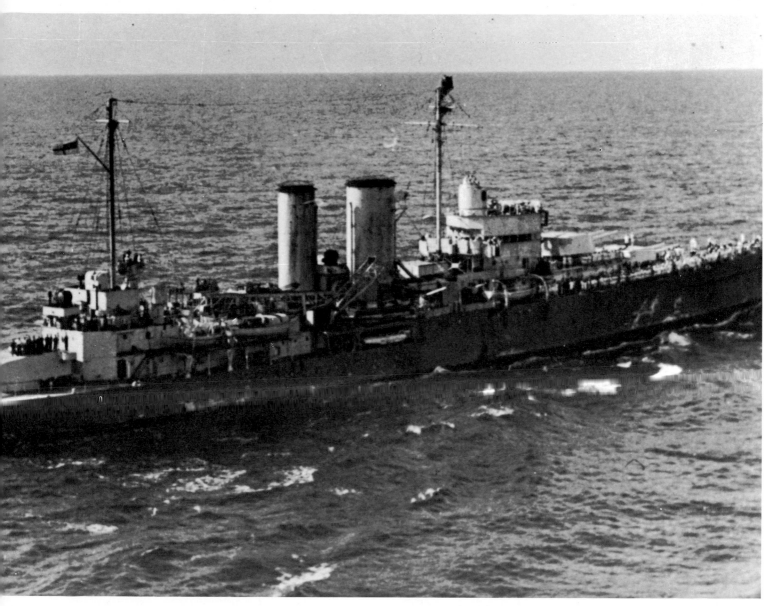

Above: The British cruiser *Exeter* seen in January 1940.
Far left: The maps show the cruise of the *Graf Spee* and the Battle of the River Plate.
Left: The cruiser HMS *Kenya* in heavy seas.

centration of British shipping there would soon attract a commerce raider, and so it turned out. At 0608 on the morning of 13 December 1939 the *Graf Spee* was sighted.

Although on paper Harwood's cruisers were at a great disadvantage it was not going to be a one-sided affair. For a start his ships were experienced and in accordance with current Admiralty orders they had exercised for such an eventuality, with the *Exeter* playing the role of attacker only a few months earlier. The principle was to use speed to retain a tactical advantage and disperse the British cruisers. This had the advantage of denying the enemy the luxury of a single easy target and permitting each cruiser to spot the others' fall of shot at long range, a process known as 'flank marking.' Unfortunately the 8-inch gunned *Cumberland* had been detached to the Falkland Islands for repairs, leaving only the light cruisers *Ajax* and *Achilles* to support the *Exeter*.

The *Exeter* inevitably bore the brunt of the *Graf Spee*'s fire. She was soon heavily hit. After an hour only Y turret remained in action, the ship was listing 7–10 degrees to starboard and was 3 feet down by the bows. She might have been worse off had the *Ajax* and *Achilles* not repeatedly darted into range and then retreated under cover of smoke. These picador tactics forced the

Graf Spee to shift target several times to chase the light cruisers off before returning to its main target. In all, three 8-inch and seventeen 6-inch hits were scored on the German ship. It is interesting to note that the *Graf Spee*'s gunnery officer later commented that the devastating effect of the 8-inch shells clearly contradicted the belief that a *panzerschiff* could only be fought by a battleship. True, Harwood's three cruisers were badly battered, but the *Graf Spee* was in a bad position, damaged and far from home, with well over half of her ammunition expended.

The *Graf Spee* finally gave up and sought refuge in neutral Uruguayan waters. Every minute spent there increased the risk of more heavy units arriving to bottle her in Montevideo. In fact only the *Cumberland* arrived but adroit propaganda led the Germans to believe that the battlecruiser *Renown* and the carrier *Ark Royal* were only a few hours away. With shell-holes in her forecastle the *Graf Spee* dared not face the North Atlantic in winter without serious risk of flooding, while other damage would probably prove the last straw for her diesel motors. With all these problems Captain Langsdorff decided to scuttle his ship, a decision supported by Hitler, who could not bear the thought of a major German warship being sunk in battle. On the evening of 17 December, the *Graf Spee* moved just outside territorial waters and sent her crew away to a German steamer. Then, suddenly, she erupted in smoke and flame as the scuttling charges wrecked the ship.

The Battle of the River Plate gave a well-deserved fillip to

British morale in the middle of the Phony War and dispelled forever the myth of the pocket battleship. Even though the *Deutschland* had returned to Germany safely a month earlier, her haul of two ships totalling less than 7000 tons was meager. The German Navy recognized their shortcomings as well, and reclassified the two survivors as heavy cruisers in 1940. Hitler even insisted on changing *Deutschland*'s name to *Lützow* because her loss would damage German prestige!

The North Atlantic Theater

The German cruiser force was small enough in September 1939 but the Norwegian campaign in 1940 cut it to the bone. First to go was the new *Blücher*. She was steaming up Oslo Fjord ahead of the *Lützow* (the former *Deutschland*) and the *Emden* in the early hours of 9 April 1940, intent on occupying Oslo. Boldness had got the force two-thirds of the way up Oslo Fjord but when it reached the dangerous Drobak Narrows its luck ran out. The reservists manning the obsolescent 11-inch guns on the island fortress of Kaholm stood to their posts and opened fire as the *Blücher* entered the Narrows. The first salvo struck home and just over a minute later two torpedoes, fired from underwater tubes on Kaholm also hit. The *Blücher* was doomed and two hours later she capsized and sank.

On 10 April the light cruisers *Königsberg* and *Karlsruhe* were struck down, one by British dive bombers while lying off Bergen and the other by torpedoes from the submarine *Truant* off Kristiansand. The *Leipzig* had been badly damaged four months earlier by a British torpedo and the *Admiral Hipper* had been rammed by the British destroyer *Glowworm* on 8 April while heading for Norway. This left the *Kriegsmarine* with only the *Emden*, *Nürnberg* and *Köln* to support Hitler's projected 'Sealion' invasion of Britain after the fall of France.

The *Admiral Hipper* was repaired and sent out into the Atlantic at the end of 1940. As with other German warships her machinery was a constant headache, and her maximum speed was soon down to 25 knots. Had the British known this they might have turned it to advantage when on Christmas Eve 1940 the cruisers *Berwick*, *Bonaventure* and *Dunedin* met the *Hipper*. They were covering a convoy of troop ships bound for North Africa, and although she hit the *Berwick* twice the *Hipper* beat a hasty retreat.

On 22 May 1941 the heavy cruiser HMS *Suffolk* caught sight of two big ships close to the pack-ice in the Denmark Strait. She and the *Norfolk* had been stationed there to spot the battleship *Bismarck* and the heavy cruiser *Prinz Eugen* if they should try to break out into the Atlantic. Although the *Bismarck* fired ranging salvoes at the *Norfolk* the two cruisers managed to stay out of trouble, and the German Admiral Lutjens knew that other British ships would soon make contact. During the next day and the following night the *Suffolk*'s radar continued to track the German ships.

The two cruisers might have hoped that their risky pursuit was over when the British battlecruiser squadron came up at first light on the morning of 24 May. However, the *Hood* quickly blew up after a fire had started. The exact cause of the explosion will never be known, but it is known that the fire amidships was caused by the *Prinz Eugen*'s shells, not the *Bismarck*'s, another example of the unforeseen potency of 8-inch gunfire against capital ships.

During the subsequent chase the *Suffolk* and *Norfolk* hung on grimly. On the morning of 27 May, only three days after the destruction of HMS *Hood* they handed over their quarry to the battleships *King George V* and *Rodney* of the Home Fleet. Again a cruiser intervened with effect in a battleship action, for the first decisive hit was scored when HMS *Dorsetshire*'s 8-inch shells knocked out the *Bismarck*'s fire control.

Early in 1942 the battlecruisers *Scharnhorst* and *Gneisenau* and the *Prinz Eugen* made their audacious daylight run through the English Channel from Brest but it was a 'strategic withdrawal' from the Atlantic rather than a shift of any offensive significance. Thereafter German raiders might lurk in Norwegian Fjords and threaten convoys heading to north Russian ports but the danger to the Atlantic convoy system diminished.

The first few convoys to Murmansk were not molested, but PQ-13 ran into trouble in March 1942, when attacked by three large German destroyers. The cruiser HMS *Trinidad* had already done sterling work for the antiaircraft defense of the convoy and now her 6-inch shells smashed into the German leader *Z.26*. However when she attempted to fire a torpedo the intense cold froze the gyroscope so that the torpedo circled and plunged into the cruiser's own starboard boiler room. She managed to limp into Murmansk three days later. There she was repaired with a

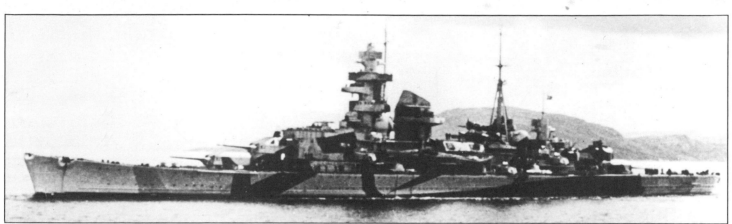

Top: The German heavy cruiser *Admiral Hipper* on 2 July 1942. The *Hipper* had been based at Trondheim but was sent north on that day to form part of the threat to the ill-fated convoy PQ-17.
Above: The light cruiser *Karlsruhe* was refitted in 1939 to improve stability by adding four feet to the beam.
Below: The heavy cruiser *Blücher* seen before the outbreak of war. The *Blücher* was lost in Oslo Fjord in 1940.

massive metal patch and she was ready to return home to England in May. However she came under heavy air attack, one bomb blowing in the temporary patch while another set her on fire forward. Although she was still steaming at 20 knots, with her steering intact, the fire gained control and eventually the *Trinidad* was abandoned.

On 30 April another valuable cruiser, the *Edinburgh*, was lost while attached to a slow convoy. She fell victim to a torpedo from *U.456* being hit twice on the starboard side. Next day she was attacked by three German destroyers. Although capable of only 8 knots and forced to steam in circles, the *Edinburgh* was game to the end. When the *Hermann Schoemann* came dashing out of a snowstorm it took only two salvoes from the *Edinburgh*'s single

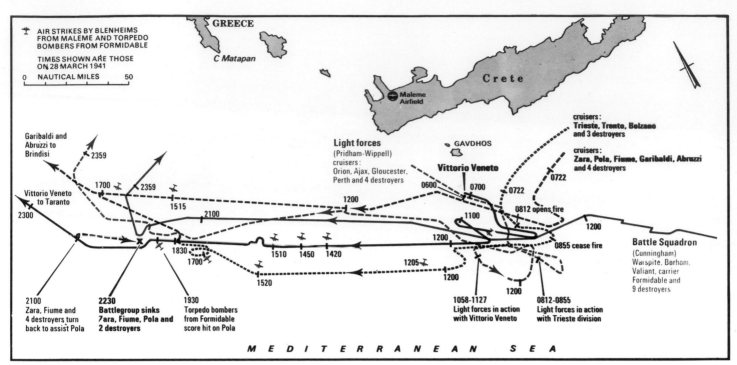

serviceable turret to cripple her. But the *Edinburgh* was hit by a third torpedo and she had to be abandoned.

The loss of these two cruisers forced a change in convoy tactics. From then on cruisers were kept away from the convoy, close enough to return if a surface attack developed but never close enough to provide the heavy AA defense which was so valuable in breaking up concentrated air attacks.

The disastrous story of convoy PQ-17 in July 1942 has been told many times. One cannot avoid comparing the actual fate of the scattered ships at the hands of U-Boats and bombers with the theoretical outcome of an attack by the *Tirpitz*, *Admiral Hipper* and *Admiral Scheer*. The commander of the covering force had four heavy cruisers and planned to use them as boldly as Harwood had at the River Plate. Nobody can tell whether such stratagems would have worked against a resolute attack, but the history of other cruiser actions shows that the *Kriegsmarine* was rarely able to match such tactics. As it was, only 11 of the original convoy of 37 reached a Soviet port.

The Battle of the Barents Sea at the end of 1942 shows what might actually have happened to PQ-17 if the local commanders had been left to work out the defense for themselves. On the morning of 31 December the convoy JW-51B was attacked. The close escort under Captain Sherbrooke comprised six destroyers and the distant escort under Rear-Admiral Burnett was made up of two 6-inch gunned cruisers, the *Sheffield* and the *Jamaica*. The German commander, Vice-Admiral Kummetz, hoped to bring the *Admiral Hipper* and three destroyers into action on the convoy's port quarter, forcing it to veer away to the southeast – right into the path of the *Lützow* and her destroyers. What in fact happened was that the destroyer HMS *Achates* laid a dense smoke screen while the other destroyers exchanged a desultory fire with the enemy at a range of about five miles. The visibility was poor, with snow squalls and patches of smoke making it necessary to fire by radar. Neither side was shooting well, the British destroyers' violent motion and constant icing up of gunbreeches made it all but impossible to fire steadily, but the much bigger *Admiral Hipper*'s shooting was equally erratic. However now the *Sheffield* and *Jamaica* were only 12 miles away, closing rapidly and totally undetected by Kummetz. Fortuitously a heavy snowstorm brought a temporary respite to Sherbrooke's destroyers and they escaped further punishment.

Although the defense had slowed the progress of the German plans they were working out as desired, for the British were being forced in the direction of the *Lützow*. However, because of

the snowstorm, the *Lützow*'s captain, mindful of Hitler's instructions to take no risks, stood off to the east while the weather cleared.

The *Hipper* made contact again but wasted her fire on the *Achates*, still laying the smoke screen which hid the precious convoy. She had just shifted fire to another destroyer when a salvo of 6-inch shells from the *Sheffield* fell around her. The fourth salvo hit, and the startled *Hipper* hauled around in a circle to make her escape, but not before the British cruiser scored another two hits. Kummetz had strict orders about action with heavy units and withdrew to the west at top speed with the *Sheffield* and *Jamaica* in hot pursuit. Two luckless German destroyers, mistook the British for their own forces in the gloom, and closed in. The *Richard Beitzen* escaped but the *Friedrich Eckholdt* was destroyed.

The *Lützow* finally managed to make contact with the convoy but could only inflict splinter damage on one ship before the destroyers forced her away. With obvious relief her captain received orders from Kummetz to rejoin the flagship. There was one more brief exchange of fire before the German force retreated. Burnett had no intention of being lured away from the convoy, being content to have his two light cruisers put to flight a pair of ships armed with 8-inch and 11-inch guns.

The *Tirpitz* was never brought to action in the open sea but the battlecruiser *Scharnhorst* made one final attempt to destroy a Murmansk convoy almost exactly a year after the Barents Sea débâcle. Once again the convoy's cruiser escort saved the day, with the *Belfast*, *Sheffield* and *Norfolk* engaging the *Scharnhorst* without regard for the risk. An 8-inch shell from the *Norfolk* destroyed the battlecruiser's forward gunnery radar set, and all the time she was trying to work her way around the cruisers the Home Fleet was coming up in support. This time the covering force included the battleship *Duke of York*, whose 14-inch salvoes blasted the *Scharnhorst* and inflicted serious damage. It was left to the cruisers *Belfast* and *Jamaica* to finish her off with torpedoes.

The Mediterranean

Much was hoped for from the fast Italian cruisers but they got off to an inauspicious start. In July 1940 the *Bartolomeo Colleoni* and *Giovanni delle Bande Nere* were attacked by the Australian cruiser *Sydney* and five destroyers. Although the Italians had been credited with 37 knots their sea speed was only 30 knots, and so it came as something of a surprise to the *Sydney*'s captain

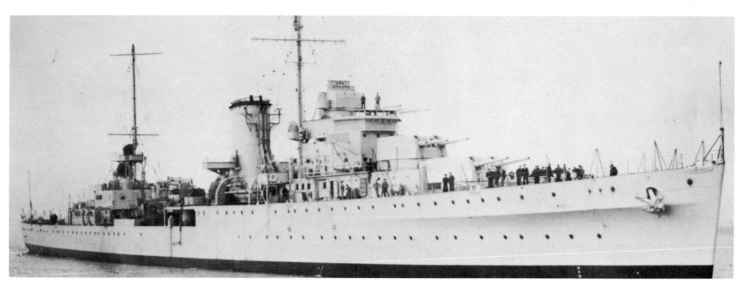

to find that he was overhauling the enemy. During the long-range gunnery duel which followed, the *Sydney*'s 6-inch salvoes hit and disabled the *Bartolomeo Colleoni* but her consort escaped.

The theory that armored 8-inch gun cruisers were a substitute for battleships was shown to be woefully wrong at the Battle of Cape Matapan on the night of 28 March 1941. The *Pola* had been hit by an aircraft torpedo earlier in the day. In the hope of towing her back to port, Admiral Iachino sent her two sisters to look for her after dark. By a series of coincidences the three ships were caught together by the British Commander in Chief, Admiral Cunningham, leading his force of three battleships. In the merciless glare of searchlights the *Fiume* and *Zara* were destroyed by 15-inch salvoes at less than 4000 yards. Then Cunningham's destroyers finished off the *Pola* and two destroyers. It was a victory which curbed any initiative the Italian Navy might have had, so that only two months later the British were left to complete the evacuation of Greece and Crete under only air attack rather than a combined air and sea assault.

In fact the air assault was deadly by itself. The evacuation of Crete cost the Royal Navy dear, particularly in cruisers. At first things seemed to go well, despite the crippling of the *York* by Italian explosive motor boats in Suda Bay, Crete. On the night of 21 May 1941 the *Dido*, *Ajax* and *Orion* and four destroyers wiped out an invasion convoy bound for Crete in commandeered fishing craft. However the next day Stuka dive-bombers sank the *Gloucester* and the *Fiji* after they had fired away all their 4-inch AA ammunition. Thereafter cruisers were warned not to allow their reserves of AA shells to fall below 40 percent.

The antiaircraft cruisers came into their own in the Mediterranean, where their lower endurance did not matter. Losses were particularly heavy, *Calypso*, *Cairo*, *Naiad*, *Bonaventure* and *Hermione* were torpedoed and *Coventry*, *Calcutta* and *Spartan* were sunk by air attack. In addition the *Carlisle* was so badly damaged that she was laid up at Alexandria and never repaired. In all 17 AA cruisers were lost.

The Italians were also suffering steady attrition from British aircraft and submarines. The old armored cruiser *San Giorgio* and the *Trieste* and *Muzio Attendolo* were sunk in port by bombing. The *Trento*, *Giovanni delle Bande Nere* and *Armando Diaz* were torpedoed by submarines and the *Gorizia*, *Bolzano*, *Taranto* (formerly the German *Strassburg*) and *Bari* (formerly the German *Pillau*) fell into German hands at the time of the Italian Armistice in September 1943. In addition, the *Alberto de Giussano* and *Alberico da Barbiano* were sunk in a night action by British and Dutch destroyers off Cape Bon. The disaster was compounded because the two cruisers were carrying an inflammable cargo of gasoline on deck, intended for the army in North Africa; both ships burst into flame immediately and sank with heavy loss of life. It transpired that the Italian Naval HQ had told Admiral Toscano of the presence of four Allied de-

Above: The British light cruiser *Ajax* served at the Battle of the River Plate and at Matapan.
Far left: Map of the Battle of Matapan.

stroyers, but it was considered that they would never dare attack two fast cruisers and their own destroyer escort.

Cruisers played their final part in the Mediterranean campaign in 1944 when they supported the Allied landings at Anzio. As they had shown in the Torch landings in North Africa and were to show in Normandy, cruisers were ideal for providing fire support. Although lacking the range and power of battleships they drew less water and could be risked more readily. Their high speed also gave them a measure of immunity from enemy shore batteries. It was a pattern which was to be repeated 30 years later, during the Vietnam War.

Below: The burning wreck of the old *San Giorgio* seen in Tobruk harbor on 22 January 1941.

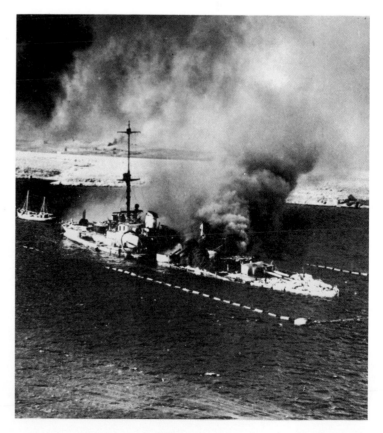

ACROSS THE PACIFIC

If the struggle between Fascism and Democracy began long before the outbreak of World War II the struggle between the United States and the Japanese Empire cast its shadow equally far ahead. Yet, although the invasion of China strained relations between the two countries, and in spite of attacks on British and American gunboats on the Yangtze and other incidents, the peace held until 7 December 1941.

Although the first cruisers in action were the USS *Honolulu* and *Raleigh*, attacked at Pearl Harbor, and the old Japanese armored cruiser *Idzumo* which sank the British gunboat *Peterel* at Shanghai, the first proper cruiser actions took place in the East Indies. A hurriedly organised American-British-Dutch-Australian (ABDA) Command was set up to defend the East Indies but it was at best a ramshackle arrangement, with too few ships, planes and men. The first losses were to air attack in the Makassar Strait on 4 February 1942. The Dutch *de Ruyter* escaped with only minor damage but the USS *Houston* had her after 8-inch turret destroyed and the *Marblehead* was hit in her steering gear.

Admiral Doorman, the Dutch naval commander, did his best

to fight back, and on 19 February his forces engaged the Japanese off Bali in the Battle of Badoeng Strait. He had the *de Ruyter* and *Java* with three destroyers in one group and the *Tromp* and four American destroyers in another. When the two forces made contact there were only three Japanese destroyers facing the *de Ruyter* and *Java* and their three destroyers. In the confused action which followed the Dutch *Piet Hein* was torpedoed without any loss to the Japanese. Then the second ABDA group arrived. Without even a common codebook the newcomers could not identify the recognition signals being flashed at them, and so made little contribution to the battle. The light cruiser *Tromp* was badly knocked about, while the three Japanese destroyers were all damaged.

Doorman was deprived of the *Tromp*, which returned to Australia for repairs, but by mid-February he had been reinforced by the British *Exeter*, repaired and modernized after the Battle of the River Plate, the *Dragon* and *Danae*, the Australian *Hobart* and *Perth* and the USS *Houston*, *Marblehead* and *Boise*. Against him were ranged a force of carriers, seaplane tenders and destroyers, as well as 11 heavy cruisers and four light cruisers. Only a few of these ships were concentrated for the Battle of the Java Sea on 27 February which nonetheless spelled the end of the ABDA force.

The Allied ships were completely out-fought and the result was never in doubt. The ships were outclassed and their crews were exhausted. The destruction began when the *Exeter* was set on fire by an 8-inch shell from the *Nachi* and minutes later the destroyer *Kortenaer* blew up from a torpedo hit. Doorman broke away, having failed to get at the invasion transports which had been his main target, but his force was in a sorry state. The *Exeter* managed to hold a straight course parallel to the southeast in company with four destroyers, while the other cruisers formed themselves into a second column about 10,000 yards away. But the Japanese were not going to let them go and by 1715 they were in range again, firing 8-inch salvoes and torpedoes. The *Exeter* was now making only five knots and she was the target chosen by the *Jintsu* and *Naka* and their destroyers. Only the bravery of two escorting destroyers saved her, and although the *Electra* was sunk the cruiser managed to limp back to Surabaya.

The rest of the force were not so fortunate. Later that night the *de Ruyter* was torpedoed by the *Nachi* and *Haguro*, sinking with Admiral Doorman and 344 officers and men on board. Five minutes later the *Java* also burst into flame after a torpedo hit, leaving only the *Houston* and *Perth* to make their way back to Batavia as best they could. Now it was *sauve qui peut* as all units tried to escape to Australia or Ceylon. The *Exeter* and *Encounter* were hunted down by the *Ashigara* and *Myoko* on 1 March, while

The *Omaha* Class light cruiser *Raleigh*, heavily damaged after the Pearl Harbor attack. The *Raleigh* was repaired and served mainly in the North Pacific until 1945.

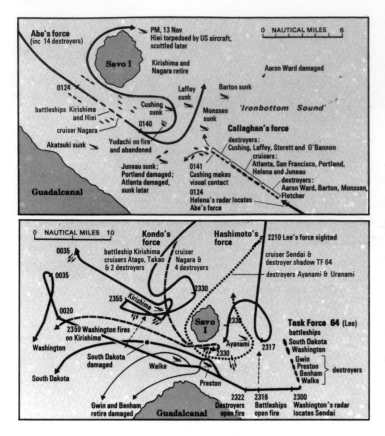

the same day saw the end of the *Houston* and *Perth*. However they wrote a magnificent ending to the story of ABDA by charging the Japanese invasion transports lying in Bantam Bay. For a while confusion reigned and the Japanese destroyers fired at one another in their haste to fend off the two Allied cruisers. Although both ships paid the inevitable price, the transports had been damaged, although mainly by the Japanese shells and torpedoes.

So far all had gone in favor of the Japanese but the Battles of the Coral Sea and Midway brought their headlong advance under control. Cruisers played no special role in these two carrier battles but they demonstrated their efficiency as screening ships for the carriers, with ample speed to keep up with them and provide a heavy AA battery. At Midway the Japanese deployed seven cruisers while the Americans had eight (including two Australian ships). Only when the fighting shifted to the Solomon Islands in August 1942 did cruisers come into their own.

Guadalcanal and the Solomons generally were important because they were on the route of the Japanese advance. The Americans were alarmed by reports that Japanese engineers were building an airfield on Guadalcanal and so on 7 August the US Marines stormed ashore to seize it. The airfield, renamed as Henderson Field, was the key to the Solomons for, as long as it was in US hands, all Japanese forces could be attacked within a 250-mile radius. Equally, in Japanese hands it would make naval operations in support of the Marines all but impossible.

It was clear that the Japanese would spare no effort to dislodge the Americans. The day after the landings a force of five heavy and two light cruisers under Admiral Mikawa left Rabaul for Guadalcanal, intent on smashing their way through the Allied warships in Savo Sound to allow transports to land reinforcements on Guadalcanal. By a series of mischances, sightings of Mikawa's force were not relayed to Rear-Admiral Crutchley, commanding the force of Allied cruisers lying off Savo Island. Nor did two patrolling destroyers spot the Japanese cruisers gliding past in the dark.

When Mikawa attacked at 0143 his force had the Allied cruisers at their mercy. In the light of flares dropped by floatplanes they riddled the Australian *Canberra* with 8-inch shell-

fire and then torpedoed her. Four minutes later the *Chicago* had her bow blown off by a torpedo. Moving north the Japanese now dealt with the USS *Quincy*, *Astoria* and *Vincennes* in turn. Surprise was complete and only the *Quincy* managed to retaliate, hitting the *Chokai* three times before sinking. The Japanese ships vanished as silently as they had arrived, leaving carnage behind them. Four heavy cruisers were sunk and one badly damaged in return for only slight damage to the flagship *Chokai*. The only comfort that the Allies could draw was Mikawa's failure to sink any of the transports lying off Lunga Point. The heavy cruiser *Kako* was also sunk by an American submarine during the run back to Rabaul.

The Japanese Navy continued to do its utmost to help the Army, running troops in under cover of darkness and bombarding Henderson Field at night. These fast runs down the island chain from Rabaul soon became known as the 'Tokyo Express' and under Rear-Admiral Tanaka they were conducted with audacity and skill. Without the benefit of radar the Japanese lookouts could still be relied on to make the first sighting and their designers' wisdom in providing the cruisers with torpedoes gave them a great advantage. Above all the attention paid by the Japanese to night fighting tactics gave them an edge in many of these actions.

In October 1942 the Americans decided to run a convoy of their own reinforcements into Guadalcanal, and this brought on a near disaster off Cape Esperance on the night of 11–12 October. The close escort for the convoy was Task Force 64 under Rear-Admiral Scott, with the heavy cruisers *San Francisco* and *Salt Lake City* and the light cruisers *Boise* and *Helena*, with five destroyers. The Americans fully expected the Japanese to try to stop the convoy but in fact its arrival had gone undetected. What the Japanese were intending was a night bombardment of Henderson Field by three heavy cruisers and two destroyers. As the Americans had foreknowledge of their time of arrival they were confident that they could get their revenge for Savo Island.

At 2235 Admiral Scott formed his force into line ahead, three destroyers leading the four cruisers and two more bringing up the rear. The Japanese Admiral Goto's force was also in line ahead but with a destroyer on either beam of the leading cruiser. Both sides made mistakes; Goto's lookouts sighted a burning floatplane but the Japanese commander did not interpret the information correctly, while the *Helena* picked up the Japanese force on her radar but failed to report the sighting for 15 minutes. The Americans had hoped to use their cruisers' floatplanes to drop flares as the Japanese had at Savo Island but their performance was disappointing. What information did reach the

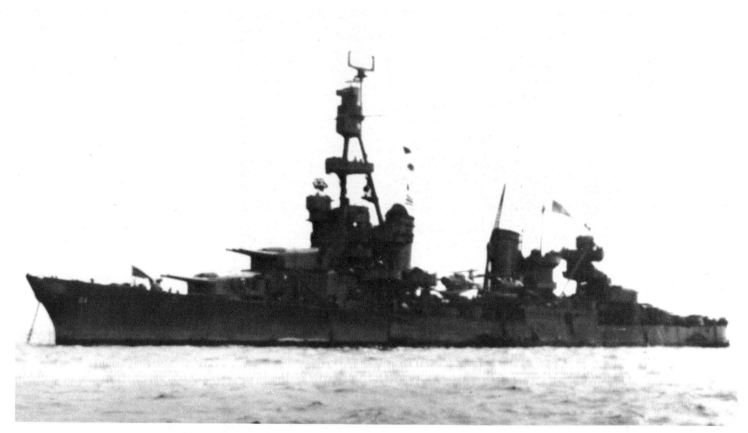

flagship was garbled, so the tactical advantage was largely thrown away.

At 2346 the *Helena* opened fire on the flagship *Aoba* and the destroyer *Duncan* shot at the *Furutaka*. Admiral Goto was mortally wounded and the *Furutaka* was set on fire but the other cruiser, the *Kinugasa*, and the destroyer *Hatsuyuki* managed to obey Goto's last order to reverse course, and escaped serious damage. The Japanese were still very dangerous, and at midnight the *Kinugasa* surprised the *Salt Lake City* with uncomfortably accurate salvoes at 8000 yards. Then the *Boise* was hit four times and was only saved when the *Salt Lake City* steamed between her and the Japanese ships. The *Boise* was lucky to escape, for an 8-inch shell penetrated her forward turret while a 6-inch shell caused a bad explosion in her magazines.

Above: The heavy cruiser *Pensacola* carried ten 8-inch guns.
Far left: Both phases of the Naval Battle of Guadalcanal.

The *Furutaka* finally sank after many hits. The *Aoba*, however, survived an estimated 40 hits from 6-inch and 8-inch shells and was still making 30 knots at the end of the action, and the *Kinugasa* had only trifling damage. It had been a scrappy, inconclusive battle with both sides achieving their main objective of getting their troops safely ashore.

The next major action, the Battle of Guadalcanal on 13–14 November, did not go well for the Americans. On the first night

Below: The *Atlanta* Class antiaircraft cruiser *San Juan* carried eight twin 5-inch gun mountings.

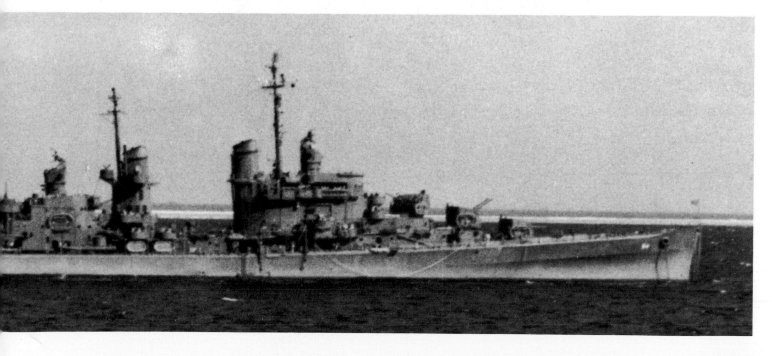

the heavy cruisers *San Francisco* and *Portland*, the light cruiser *Helena* and the AA cruisers *Atlanta* and *Juneau* ran into a force which included the battleships *Hiei* and *Kirishima* and the light cruiser *Nagara*. Once again it was the *Helena*'s efficient radar which detected the enemy but she was positioned towards the rear of the column, a difficult position for it to function effectively. Again poor radio discipline overloaded the voice net with messages, with the result that Rear-Admiral Callaghan could make little sense of the reports.

The *mêlée* which ensued has been described as the most confused and horrifying naval action of the entire war. Callaghan's force did not know that it had charged right into the middle of the Japanese squadron until the *Atlanta* was illuminated by the searchlights of the *Hiei* and the destroyer *Akatsuki*. The battleship's 14-inch shells ripped into the flimsy superstructure, killing Admiral Scott. The *Atlanta* was then torpedoed, having managed to fire only one salvo. However the two Japanese ships were immediately fired on by the American destroyers and drew away; the *Akatsuki* was sunk shortly afterwards and the *Hiei*'s upperworks were set on fire. In the confusion the *San Francisco* started to fire on the *Atlanta* but soon realized her mistake. Only seconds later she herself was hit by 14-inch salvoes from the *Kirishima* and 5-inch fire from two destroyers. The *San Francisco*'s bridge was destroyed and Admiral Callaghan and his staff were killed.

The battle now degenerated into a sort of dogfight. Admiral Abe in the burning *Hiei* had lost control of his ships and the two American admirals were dead. Individual ships fired at whatever

Above: The heavy cruiser *Quincy* on 4 August 1942.
Far right: The *St Louis* leaves Tulagi anchorage in 1943.
Below: The *Minneapolis* sails out of Pearl Harbor.

targets they could see. In these conditions the Japanese were more likely to win, thanks to their superior training. The *Nagara* and the destroyers sank the destroyer *Barton*, crippled the *Portland* with a torpedo and set the AA cruiser *Juneau* on fire, before raking the *San Francisco* with gunfire. The *Helena* gave a good account of herself at first, using radar-controlled gunfire to drive off the *Amatsukaze* but she was then badly mauled by three more Japanese destroyers. When the firing died away at 0200 two Japanese destroyers and the *Hiei* were doomed (she would be sunk the next day by aircraft) but the Americans had lost two destroyers and an AA cruiser and had several badly damaged. The *San Francisco* and *Helena* survived but next day the battered *Juneau* was torpedoed by a Japanese submarine and two more destroyers had to be abandoned.

Another battle was fought the following night between two US battleships and a Japanese force comprising the *Kirishima* and the cruisers *Sendai*, *Nagara*, *Atago* and *Takao*. Once again there was confusion but the Americans got the better of the exchange, and the *Kirishima* was sunk by 16-inch shellfire from the *Washington*. Aircraft from Henderson Field had also caught Admiral Mikawa's bombardment force at daybreak the day

before, sinking the *Kinugasa* and damaging the *Chokai*, *Maya* and *Isuzu*. The Japanese could not accept losses on this scale and when an air strike devastated a reinforcement convoy brought in by 'Tenacious Tanaka' on 14 November it was the beginning of the end. Although the 'Tokyo Express' continued to run there was no longer any hope of supporting the Army by bringing on a full-scale naval battle. From now on the Japanese would be in retreat.

There were to be other battles in the Solomons but they were fought around the 'Tokyo Express', which began to reverse the process by steadily evacuating the garrison from Guadalcanal. The Battle of Tassafaronga on the night of 30 November/1 December showed that even if the Americans ruled the sea by day the Japanese ruled at night. Four US cruisers, the *Minneapolis*, *New Orleans*, *Pensacola* and *Northampton* were torpedoed in quick succession by eight destroyers under Tanaka's command. Good damage control saved three of them but the *Northampton* caught fire and had to be abandoned.

Much of the Japanese success in these night actions depended on the long accurate running of the 24-inch 'Long Lance' torpedo. Eventually cruisers provided the solution, using their

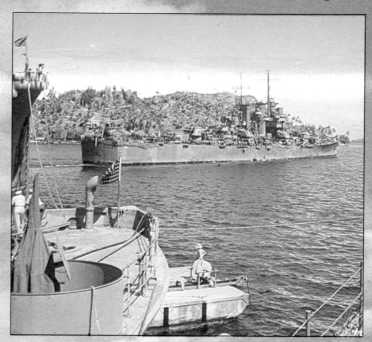

6-inch and 8-inch guns with radar control to lay down barrage fire at maximum range. This technique was used successfully by Rear-Admiral Merrill in the Battle of Empress Augusta Bay in November 1943. The new light cruisers of the *Cleveland* Class were coming forward, armed with twelve 6-inch guns and equipped with the latest fire-control radar. The rapid fire of the 6-inch was better suited to this sort of action than the 8-inch, and so the new *Baltimore* Class ships were more usually allocated to the carrier task forces.

Once the United States and other Allied forces broke out of the Solomons cruisers were usually confined to the less glamorous roles of carrier escort and shore bombardment. As ever the cruiser could make up in numbers for the small amount of battleships and there was no diminution of their importance. The US Navy had started an enormous program of cruiser construction early in 1942 to supplement the 1940 'Two-Ocean Navy' program. Three basic types were in hand, the *Cleveland* Class light cruisers, the *Baltimore* Class heavy cruisers and also the *Atlanta* Class antiaircraft cruisers.

The 10,000-ton *Cleveland*s were a development of the prewar *Brooklyn*s, sacrificing the redundant fifth triple 6-inch turret for a heavier AA battery of six twin 5-inch guns. They set a record as the largest class of cruisers ever ordered. Even allowing for nine converted to light aircraft carriers 30 were completed between 1940 and the end of the war. The *Baltimore* Class resembled the *Cleveland*s in being flush-decked with two slim capped funnels but their designers were now free of the 10,000 ton limit and so they rose to 13,600 tons – proof that the original limit had been too small for a balanced design.

These two classes were a logical progression from previous US cruisers but the third class marked a radical departure. The *Atlanta* Class resembled the British *Dido* Class AA cruisers in being much smaller (6000 tons) than the standard 'fleet' cruiser. Although also intended to fulfil a fleet AA defense role with the massive armament of eight twin 5-inch dual-purpose gun mountings (three forward, two on the beam and three aft) their main role was to act as a type of destroyer-leader and fight the big Japanese 'Special Type' destroyers.

There is one more class of American cruisers to be mentioned. This is the somewhat freakish *Alaska* Class, displacing 29,000 tons and armed with nine 12-inch guns. Although loosely referred to as battlecruisers they bore no resemblance to the original type and were always rated by the US Navy as large cruisers (CB). The *Alaska* Class was built partly as a result of an erroneous intelligence assessment of Japanese intentions but mainly as a result of somewhat morbid fears that the 8-inch gun would not be adequate to protect the carriers from attack by enemy cruisers. A very fast long-range cruiser with guns ranging out to 21,000 yards made some sense, but what resulted was a very expensive ship of limited utility. Only two were

completed, the *Alaska* and *Guam* in 1944, and although they proved magnificent steamers they never justified the colossal effort which went in to building them.

Two more designs were prepared during the war, and although they were not completed until much later they show how far the cruiser could be taken. On a displacement of 17,000 tons the armament of the *Des Moines* Class remained as nine 8-inch guns but the extra weight was used to provide fully automatic loading for them. The Mark XVI 8-inch 55-caliber gun fired shells with wrapped charges at a range of 10 per minute, about four times as fast as earlier marks of 8-inch. Without doubt these ships were the most powerful cruisers ever designed (excepting the *Alaska* Class) capable of delivering a heavy volume of fire up to 14 miles away. The *Worcester* Class, at 14,700 tons, ran the *Des Moines* Class a close second but it was intended to be an expansion of the AA cruisers, using a new dual-purpose automatic 6-inch 47-caliber twin mounting in place of the 5-inch 38 caliber.

As the end of the war approached the vast American cruiser program began to slow down to release shipyard resources for landing craft. In 1944–45 35 cruisers of all types were cancelled for the US Navy now had as many as it could man. Even so several others were not completed until some time after the war was over.

The US Navy took the cruiser to its ultimate in 1941–45, producing ships of unparalleled fighting power. What characterized American cruisers was their uniformity of equipment and massive antiaircraft armaments. Although other classes of warships had their virtues it could be argued that the US Navy had more conspicuous success with its bigger cruiser designs than anyone else. Their Washington Treaty designs set them on the right road, and right through to 1945 there was little need to make more than minor improvements. The Japanese cruisers, by comparison, showed more ingenuity but caused their designers many headaches. Nothing like the disastrous story of the *Mogami* Class happened in the US Navy and apart from a premature abandonment of torpedo tubes the designs met wartime requirements.

Although the arguments against 8-inch guns had some validity, the arrival of radar on the scene finally justified the choice. With radar-controlled gunnery hits could be obtained at maximum range and therefore the extra range of the 8-inch gun was more likely to be decisive. However it was in their high endurance and mechanical reliability that American cruisers showed real superiority. As had been foreseen in 1919 the battleground was to be the Pacific and ships would have to steam immense distances. The dollars invested in machinery and boiler improvements were well spent.

Top right: Secondary armament of the *Northampton*.
Right: Blistered paint on the guns of the *Salt Lake City*.
Below: The heavy cruiser *Baltimore* seen in 1944.

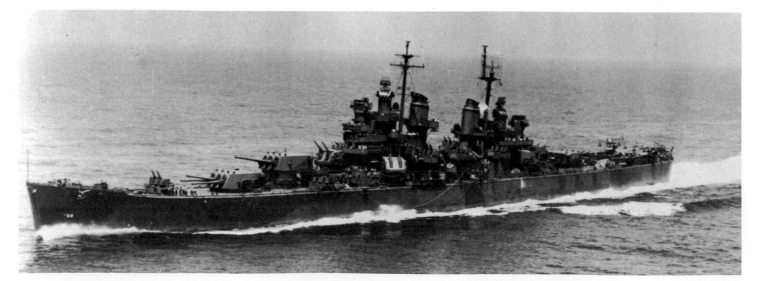

MISSILES AND NUCLEAR POWER

Even if the battleship had not been ousted from her position as the premier type of warship by the aircraft carrier, running and manpower costs made her an anachronism. In the years after 1945 there was still a need for heavy gunpower, and this combined with lower running costs to keep the cruiser in favor.

As part of the search to find an answer to the Kamikaze attacks in 1944 the US Navy initiated the 'Bumblebee' program, to develop a guided weapon capable of destroying high-speed aircraft. After a decade of development the Terrier guided missile was ready. Terrier was a big weapon 27-feet long and weighing more than a 16-inch shell without its associated fire control and radar, so there was little point in trying to install it in small warships. The logical ship to take Terrier to sea was a big cruiser and in 1954 two *Baltimore* Class, the *Boston* and *Canberra*, were taken in hand for reconstruction. When they reappeared in 1955–56 they were the world's first guided-missile cruisers.

The profile was completely altered, the entire after superstructure and triple turret being replaced by platforms carrying two twin-arm launchers, two directors on tall pedestals and a big platform for new radars. Below decks the former shell rooms and magazines were replaced by mechanical stowage and loading gear for a total of 144 Terrier missiles. Two missiles could be

Far right, top: The after 6-inch and 3-inch turrets of HMS *Blake*.
Far right: The Soviet *Kara* Class guided missile cruiser, *CG.539*.
Above right: British officers inspect the wreck of the *Hipper*, destroyed by bombing of Kiel harbor.
Below: The cruiser *Savannah* seen in Algiers in 1943. Two Liberty ships burn in the background after an air attack.

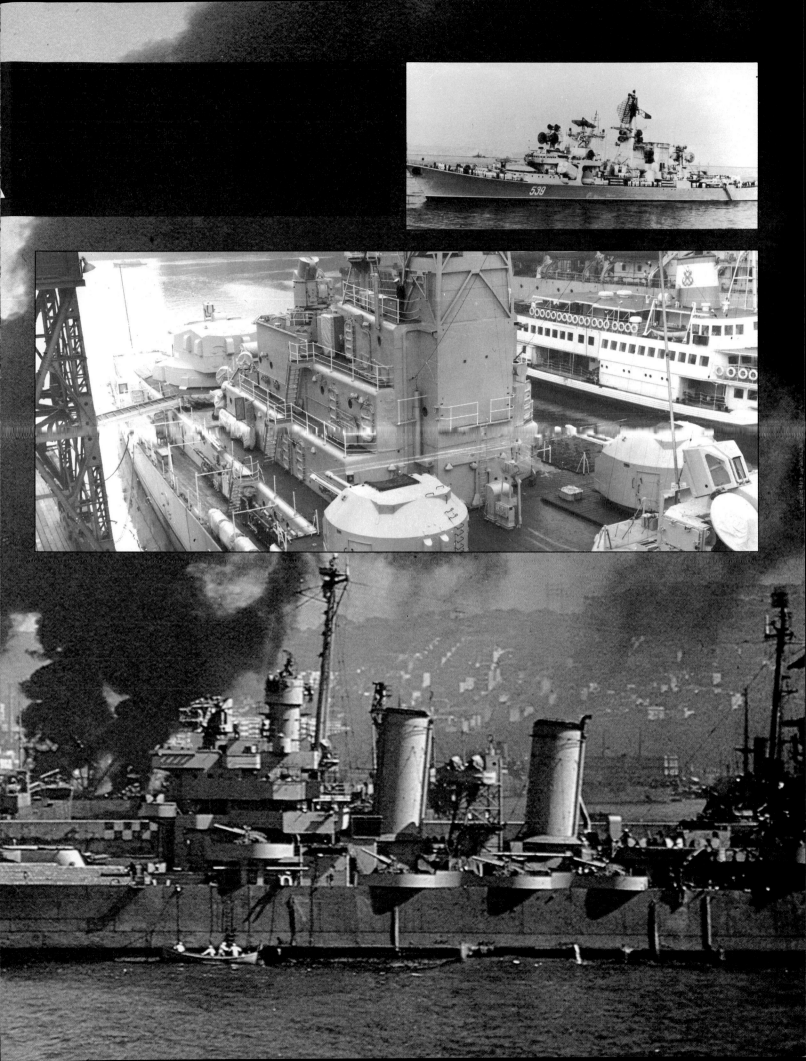

56

launched every 30 seconds. Terrier was a beam-riding missile, homing on to hostile aircraft by following a radar beam generated by the fire-control director. The success of this conversion led to six of the *Cleveland* Class being converted in 1956–60. The next conversion was much more elaborate than anything previously envisioned. The cruisers *Albany, Chicago* and *Columbus* were earmarked. The hulls were stripped down to the weather deck and entirely new superstructures built up, comprising two lofty 'macks' or combined 'mast-and-stack' with a high narrow bridge. There were twin-arm Talos missile launchers forward and aft and Tartar missile launchers on either side of the bridge. This gave superb all-round coverage, with the 70-mile Talos for long-range defense and the Tartar to deal with targets which got through the outer screen.

All three saw considerable active service after completing their reconstructions in 1963–64. In 1972 the *Chicago* covered the minelaying operation off Haiphong. When North Vietnamese interceptors were picked up on radar moving towards the mine-laying aircraft, the cruiser's Talos missiles were able to shoot down one MiG at a range of 48 miles and turn the rest away. Another use for Talos was with an anti-radiation homing head, allowing them to destroy radar sites in North Vietnam. But their hulls and steam plant were ageing fast and in August 1976 the

Columbus was struck off the effective list and her two sisters have now gone the same way.

By 1968 the original conversions were considered unsuitable for defending the Fleet against air attack because of the obsolescence of the BW-1 Terrier missile systems. Paradoxically, they proved extremely useful off Vietnam because they had retained their forward triple 8-inch guns. Both they and unconverted heavy cruisers served on the 'gun-line' in Vietnam, pounding enemy positions far more effectively than ground attack aircraft. The virtue of naval bombardment has always been that it can be sustained for as long as ammunition lasts, and its methodical and repetitive nature has a worse effect on enemy morale than occasional air strikes, however devastating.

The advantage of converting cruisers was exactly the same as it had always been; they had useful endurance and their size meant that they could carry a worthwhile number of missiles. Once the US Navy had shown the way others followed suit. The Royal Netherlands Navy rebuilt the *De Zeven Provincien* on similar lines, with a twin Terrier launcher and fire control in place of the after turret, while the Italians did much the same for the old light cruiser *Giuseppe Garibaldi*.

All these conversions of World War II cruisers suffered from the inherent problems of pressing new wine into old bottles, but

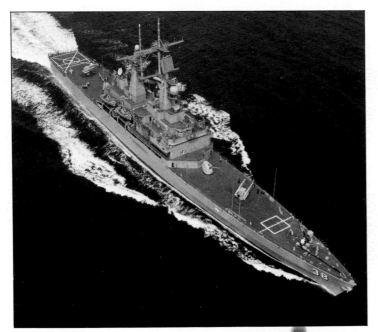

Left: The nuclear-powered cruiser *Virginia* looks under-armed but because of her elaborate fire-control systems is a very powerful warship indeed.
Top right: The old French cruiser *Jeanne d'Arc* and behind the more modern *La Resolue*, seen in 1964.
Right: The carrier *Nimitz* and the cruisers *California* and *South Carolina* seen at Norfolk Navy Yard.
Below: The profile of the French *Suffren* is dominated by her radar systems.

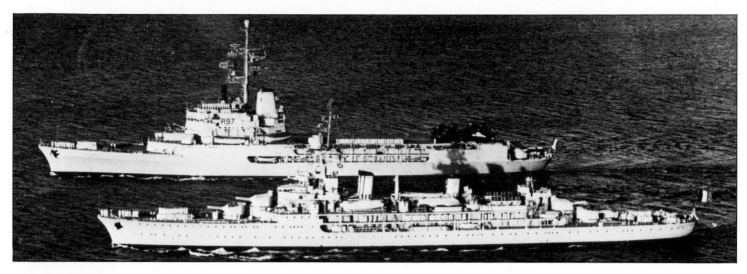

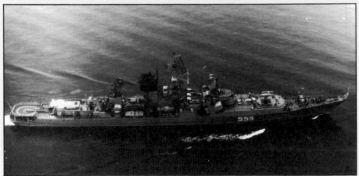

Above: The Soviet *Sverdlov* Class cruiser *Aleksendr Suvorov* seen during a Soviet exercise in the Philippine Sea area.
Left: The *Kresta II* Class cruiser *Marshal Voroshilov* photographed in 1979.
Below: The Soviet *Kirov* nuclear-powered, guided-missile cruiser on her trials in 1980. This large and powerful ship has weapons systems suited to a range of air defense, surface and antisubmarine missions.

they wrung a few more years service out of ships which might otherwise have gone to the scrapyard, and showed that the cruiser could adapt to modern warfare. In the 1950s it had been fashionable to predict that the cruiser would soon follow the battleship into obsolescence. Nobody made such a suggestion after seeing the exceptional performance of the missile cruisers in the Vietnam War.

Although most navies gave up the idea of big gun-armed cruisers after World War II there was one exception. The Soviet Union had been expanding its navy before the German invasion in June 1941 and although much of the new construction had been destroyed either by enemy action or by the Russians to keep it out of German hands, a number of hulls survived in 1945.

Joseph Stalin's naval Commander in Chief, Admiral Kuznetsov was given funds to complete five of the *Chapaev* Class. These were improved editions of the prewar *Kirov* Class, and like them had been designed with Italian technical assistance. While work was being restarted on the *Chapaev* Class a new class of slightly improved and enlarged ships was laid down. This was the hand-some *Sverdlov* Class, also mounting four triple 150mm (5.9-inch). The *Sverdlov* made a big impression in the West and speculation was rife about her capabilities, but her essentially old-fashioned features were overlooked. Looked at today, her optical range-finding equipment and low-angle main armament stamp her as a prewar design. It is doubtful if she would have made much of an impression against Western navies, but in the 1950s it was fashionable to talk luridly of the 'Sverdlov cruiser-threat.'

In all 20 *Sverdlov* keels were laid but after the death of Stalin a mood of reaction set in. Kruschev admitted as much when he told the West that he was scrapping all his cruisers and recom-mended them to do the same. As with other Soviet pronounce-ments this was not quite what happened, and only six incomplete hulls were scrapped. Unlike other navies' cruisers those surviv-ing were not reconstructed, although three were given experi-mental guided-missile installations aft.

In 1957 an entirely new type of ship was laid down, the *raketny kreiser* or 'rocket cruiser.' Known to the West under the code-name *Kynda* but actually called the *Grozny* Class, four were built between 1957–65. It is possible that as many as 12 were planned, but with eight very large missile tubes on deck, reloads in the superstructure, a surface-to-air missile launcher and

massive radars it is almost certain that severe stability problems were encountered, so the program stopped at four ships. To Western observers the massive surface-to-surface missile, code-named SS-N-3 or *Shaddock*, with its range of 170 miles gave the Soviet Navy a big advantage. Immediately they were seen to be successors to the *Sverdlov*, roaming the oceans and hunting down American aircraft carriers.

A closer look at the *Kynda* raises some doubts about the role assumed for them by most Western commentators. For one thing the 170-mile range for the SS-N-3 missiles could only be achieved if the missile received mid-course guidance, and as the *Kynda* design does not include a helicopter it must be assumed that she was intended for waters dominated by Soviet air power – not the world's oceans. This limitation is confirmed by the lack of a high-performance search radar, and the much-praised doubling up of fire-control radars, two sets were fitted, now seems to be a reflection of their lack of reliability, not a doubling of efficiency. Another interesting point is that although they were built for the Northern Fleet they were subsequently modified to reduce topweight and sent to the less demanding Pacific and Black Sea areas.

During the 1950s and 1960s there was a tacit assumption that the day of the cruiser was over. To many observers the only justification for all the cruiser conversions was their capacity to take the bulky first generation surface-to-air missiles such as Terrier and Talos.

All this changed in 1957 when the United States Navy laid the keel of a 14,000-ton nuclear-powered cruiser (CLGN 160, later redesignated CGN-160 and finally CG 9) to be called *Long Beach*. Not only was she the first cruiser built since 1945 but was also the world's first nuclear-powered surface warship and the first to be armed with nothing but guided missiles. The planned displacement was to have been 7800 tons but this rose to 11,000 tons after a second Terrier missile system was added to the design. A subsequent decision to add the long-range Talos aft (both Terrier systems were forward) pushed standard displace-ment up to 14,200 tons.

Having reactors to provide steam meant that uptakes and funnels were dispensed with, and for the first time designers could lay out the superstructure to suit themselves. The result was a big square block of bridgework with unique 'billboard' radar arrays on the outer faces, free from corrosive funnel gases and sited for maximum efficiency. Although the speed of 30 knots was modest it was constantly available and so the *Long Beach* was an ideal carrier escort. In fact after she was completed in 1961 she operated with the nuclear-powered attack carrier *Enterprise* and it was soon realized that conventionally-powered escorts were simply not suited to the task as they used so much fuel in the high-speed steaming required to keep up with the *Enterprise*.

The C1W reactors in *Long Beach* were similar to the A2W type in the *Enterprise*. Work had also started on a prototype reactor small enough to be installed in a 'destroyer-sized' ship. In 1959 the keel of the first nuclear-powered DLG or frigate was laid. The *Bainbridge* (DLGN-25) displaced 7600 tons and differed from

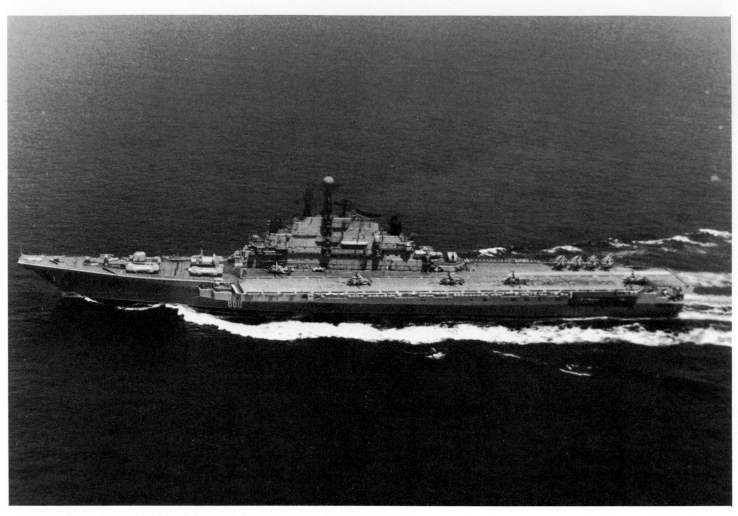

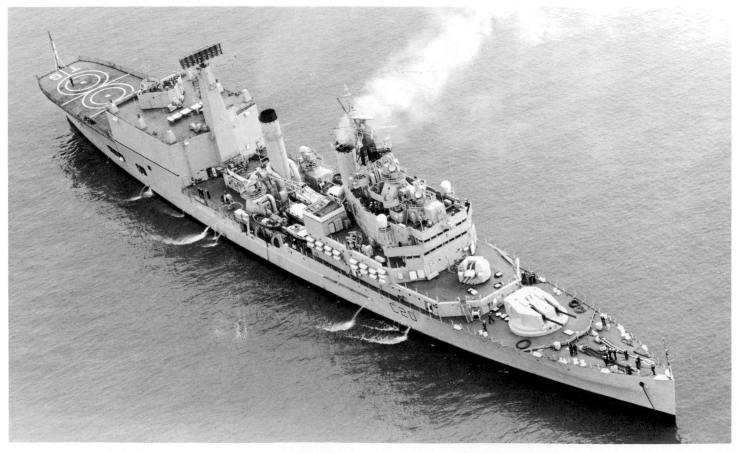

the *Long Beach* principally in having her two Terrier missile systems at either end of the ship, but no Talos. She also had rotating radar scanners on tall lattice masts instead of the 'billboards.'

The commissioning of the *Bainbridge* in 1962 gave the US Navy the world's first nuclear task force with the *Enterprise* and *Long Beach*, and there was talk of an all-nuclear navy. However, the cost was staggering, $332.85 million for the *Long Beach* and $163.2 million for the *Bainbridge*. Fiscal Year 1958 therefore included money for three 'fossil-fuelled' frigates, and six more were authorized the following year.

There was a return to nuclear power in 1962 when DLGN-35 was authorized, later to commission in 1967 as the *Truxtun*. She was in effect a nuclear edition of the *Belknap* Class, but with the 5-inch gun forward and the Terrier missiles aft. All 20 frigates in commission were reclassified as cruisers on 30 June 1975, a change which was confusing at the time, but entirely logical because of their role as fast carrier escorts.

The Soviet Navy, having pioneered the surface-strike cruiser in the *Kynda* Class, decided to rectify their more obvious faults in the next class. Work apparently started in 1964, code-named *Kresta* by NATO. When she first appeared in 1970 the *Vize-Admiral Drozd* looked quite different from her predecessors, with a massive central mack and tall radar tower. Instead of the fore-and-aft quadruple missile tubes the *Kresta* carried two pairs, one on either side of the bridge. Current Western thinking is that no reloads for the SS-N-3 *Shaddock* missiles are carried, although there might well be space for four reloads in the forward deckhouse. Two important deficiencies in the *Kynda* design were rectified; a helicopter hangar is provided right aft and the big air-warning radar is sited on the mack. The *Hormone-B* helicopter carries a radar and could provide mid-course guidance for the *Shaddock*.

The appearance of a modified version of the *Kresta* in 1970 complicated assessment of this Soviet design. The *Kronstadt* was code-named *Kresta II*. The main external difference from the four *Kresta I* was the redesign of the pyramidal tower amidships

Above: Stern view of HMS *Bristol* showing her Sea Dart missile system and Type 909 radar.
Left: The Soviet 'antisubmarine cruiser' *Kiev* in 1976.
Below left: HMS *Tiger* in 1977 with hangar and flight deck aft.
Below: The Italian helicopter cruiser *Vittorio Veneto*.

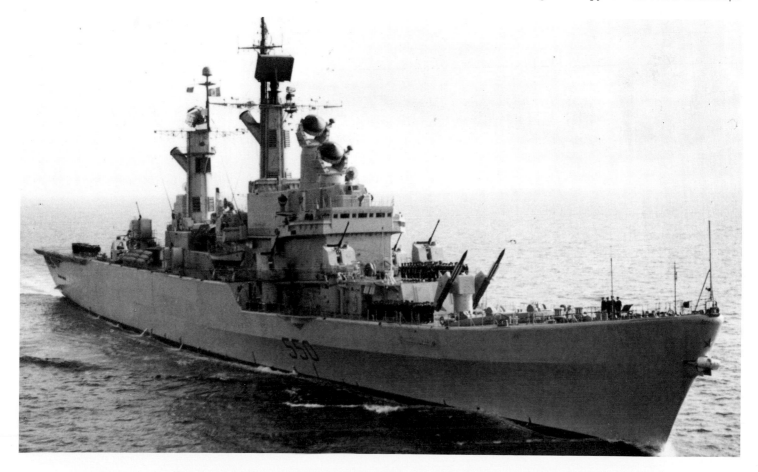

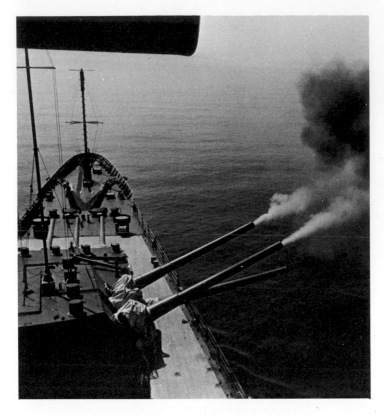

Above: Old gun-armed cruisers were used to provide shore bombardments during the Vietnam War. This is the *Canberra*.

to carry a new 3-D radar antenna and the replacement of the horizontal missile tubes by missile launchers in quadruple boxes angled up at 20 degrees. For some years this was reputed to be a new surface-to-surface missile, code-named SS-N-10. However it is now believed to be the SS-N-14, an antisubmarine missile with a range of up to 30 miles. This helps to explain the Soviet designation for the *Kresta II*, *Bolshoi Protivo Lodochny Korabl* or large antisubmarine ship, but it casts doubt over the ship's ability to defend herself or pose a threat to Western surface ships.

The *Kresta II* is clearly more successful than the *Kresta I* for 10 ships have been completed since 1970. They have been superseded by the similar but larger (8200 tons) *Kara* type. The armament of the *Kresta II* has been repeated in roughly the same layout but instead of the rather ugly mack there is a big square funnel. Although some Western authorities credit the *Kara* type with massive power and speed these are probably grossly overestimated; on roughly the same dimensions as an American nuclear cruiser capable of 30 knots she is claimed to have double the power and 34 knots.

In mid-1967 the Russians produced their first helicopter carrier, the 14,500-ton *Moskva*. She and her sister *Leningrad* are officially described as *Protivo Lodochny Kreiser* or antisubmarine cruisers. In general layout they resemble the French *Jeanne d'Arc* in having a center-line superstructure and conventional guided-missile cruiser bow, but a flight deck aft as if two different ships have been joined together. Unlike the British *Invincible* Class they are obviously not intended to operate anything but helicopters. Clearly the Soviet Navy was providing itself with a more effective antisubmarine arm by taking more ASW helicopters to sea.

Of even more significance was the next class of 'antisubmarine cruisers,' the *Kiev* Class. When she appeared late in 1976 she threw Western observers into a fever of speculation for she was clearly intended to operate fixed-wing aircraft. The presence of a flight of Yak-36 *Forger* VTOL aircraft on her flight deck immediately sparked fears that the Soviet Navy was intending to take on the US Navy on the high seas and by developing a much greater offensive capacity.

On closer examination the *Kiev* proves to be as much of a hybrid as the *Moskva*, with a heavy battery of eight SS-N-12 surface-to-surface missiles, a surface-to-air missile launcher and a twin 76mm gun mounting on the forecastle. The Yak-36 also has severe limitations as a shipboard strike aircraft in that it cannot make a short take-off, only vertical. This means that it must have much lower endurance than the Harriers used by the US Marines or the Royal Navy. In many minor respects the flying arrangements take second place to the 'cruiser' characteristics, particularly in the shapes of the forecastle and superstructure and the sheer weight of armament. The second ship of the class, the *Minsk*, does not display any major changes, so it seems likely that the Soviet designation is an accurate reflection of their hybrid nature as cruiser/carriers.

Far from being tempted to follow the Soviet line the US Navy remains convinced that the functions of aircraft carriers and their cruiser escorts are best kept apart. As long as nuclear carriers continue to be built there is a need for nuclear-powered cruisers to keep pace with them and protect them, conversely using the carrier's aircraft as part of their own defenses. This concept was amply proved in the late 1960s, when the carrier *Enterprise* and the *Long Beach*, *Bainbridge* and *Truxtun* operated together in the Vietnam War. The authorization of a second nuclear carrier, the *Nimitz* (CVN.68) in 1967 was therefore accompanied by approval for a nuclear cruiser, followed a year later by funds for a second ship.

The USS *California* (CGN.36) and *South Carolina* (CGN.37) are two of the most powerful warships in the world, and as the epitome of modern design deserve a closer look. At first glance they seem devoid of armament, with only two single-arm launchers for the Standard SM-1 missile and two lightweight 5-inch gun mountings. However, their fighting power cannot be gauged by counting gun barrels and launchers. The sensors, the surveillance and tracker radars and the massive bow-sonar, combined with a comprehensive computer suite to process their data, enable the weapons to be used far more effectively than ever before. For example the SPG-60 radar can acquire air targets at a range of 75 miles and track them automatically. It provides a fifth channel to back up the four SPG-51D missile-control trackers, and its computer can handle up to 120 different targets automatically. Thus, although only five missile targets can be engaged *simultaneously*, the computer allows rapid shifts from track to track and selection of the most urgent targets. When the more advanced SM-2 missile is available the system will become even more potent, because the missile's guidance system only requires assistance in the initial and terminal phases of its flight.

Two more nuclear carriers, the *Dwight D Eisenhower* and *Carl Vinson*, followed the *Nimitz*. To provide them with escorts four more nuclear cruisers have been built, the *Virginia* Class. They are basically similar to the *California* Class, but with many minor improvements such as a helicopter hangar and an improved missile launcher capable of launching both Standard surface-to-air and Asroc antisubmarine missiles.

The next step forward was a major improvement in weaponry based on a new fleet defense system called Aegis. The heart of Aegis is a new fixed-array radar which sends out pencil-like beams; as soon as one picks up a target several nearby beams are directed to it as well. This enables the Aegis SPY-1 radar to start a smooth tracking of the target within one second, when a conventional radar would still be completing its first rotation. With four SPY-1 radars an Aegis system provides complete coverage which the SPG-62 trackers and the SM-2 missiles can exploit to the full.

In 1968–69, when development of Aegis was well advanced, the US Navy started to plan for a fleet of 30 nuclear Aegis ships. These were to have included destroyers with only one missile launcher and cruisers with two launchers, but of these only the four *Virginia* Class were authorized between 1971 and 1975. Delays in the Aegis program then resulted in the *Virginias* getting a conventional outfit of radars and missiles.

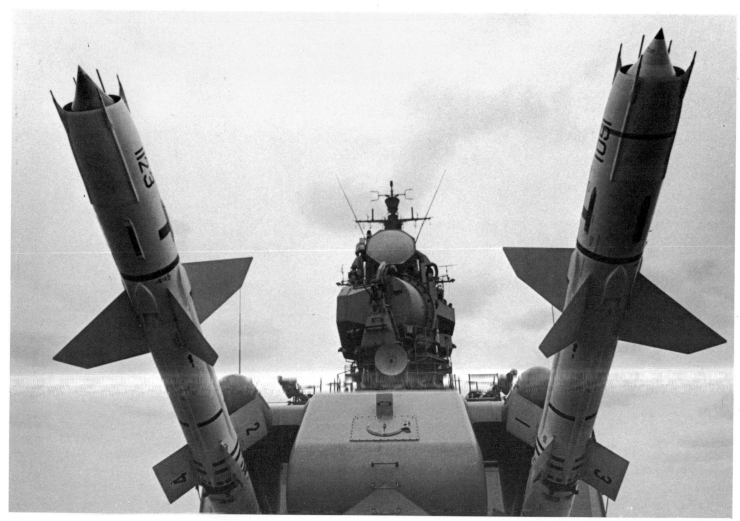

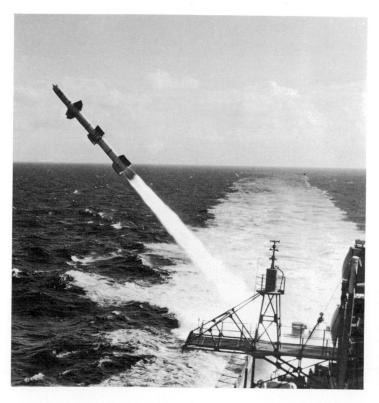

Above: Talos on the cruiser *Chicago* in 1967 off Vietnam.
Below: A missile is fired during maneuvers.

From 1975–77 Congress debated building a 17,000-ton 'Strike Cruiser', or CSGN. She was to be nuclear-powered and armed with Aegis, surface-to-air missiles and Tomahawk surface-to-surface cruise missiles, but the cost was a staggering $1500 million. Despite the vociferous claims of the nuclear lobby led by Admiral Rickover, in May 1977 the Senate Armed Services Committee gave its final verdict that the ship was too costly and over-designed for its role as a carrier escort.

The alternative was to resurrect the Aegis-armed destroyer, based on the hull of the *Spruance* Class destroyers. On a displacement of 9000 tons these destroyers are seaworthy enough to carry out a cruiser's duties, and late in 1979 the *DDG-47* Class became the *Ticonderoga* Class (CG-47). However this did not stop the authorization of four Aegis-equipped Modified *Virginia* Class in place of the eight strike cruisers requested in 1976. To help make up the numbers of Aegis systems Congress also urged that the existing *Virginia* Class should be refitted with the system as soon as possible.

As always the Soviet Union came up with a bigger and more impressive answer. In 1978 it was revealed that the Zhdanov yard in Leningrad was building a powerful 22,000-ton 'battle-cruiser' to be called *Kirov*. She is nuclear-powered and armed with air-defense and long-range surface missiles, and is presumably intended to screen the big aircraft carrier reported under construction in the Black Sea. Also building are three 12,000-ton cruisers, an expansion of the *Kara* design reputed to be called the *Sovietski Soyuz* Class. And so the cruiser-story comes full circle, with a new generation of super-cruisers about to dominate the oceans. This development, coupled with growing doubts about the cost and validity of the big strike carrier, may yet give the cruiser the prestige of being the most powerful warship type ever built.

INDEX

*Page numbers in italics
refer to illustrations*

Achilles, HMS 41
Ajax, HMS 41, 45, *45*
Alaska, USS 52
Albany, USS 56
Alberto di Guissano, Ital. *33*, 45
Amethyst, HMS 8
Amphion, HMS 17–18
Aoba 32, 49
Arethusa, HMS 18, *19*, 19
 1912 class 9, *16*, 18, 24, 28
 1936 class 36
Ashigara class 33, 47
Astoria, USS 48
Atago 51
Atlanta class, USN *49*, 50, 52
Aurora, HMS *16*, 19
Australia, HMAS 31

Bacchante, HMS *16*
Bainbridge, USS 59, 61, 62
Baltimore class, USN 52, *52*, 54
Beatty, Vice-Admiral Sir David
 18, 20, 21
Belfast, HMS 37, 44
Berwick, HMS 31, 42
Birmingham, HMS *19*, *20*, 22
 class 9
Birmingham, USS 24, *27*
Black Prince, HMS 17, 21, 23
Blake, HMS *35*
Blücher, armored cruiser 19
Blücher, 1934 cruiser 35, 42, *43*
Boise, USS 47, 48, 49
Bolsano, Italian 33, 45
Bonaventure, HMS 42, 45
Boston, USS 54
Bremse, minelayer 19, 26
Breslau 17
Bristol, HMS 15, *61*
 class 8
Brooklyn class, USN 36, 37, *37*, 52
Brummer, minelayer 19, 26

California, USS *57*, 62
Calliope, HMS *19*, 22
Canberra, HMAS 31, 48
Canberra, USS 54, *62*
Canterbury, HMS 21
Cardiff, HMS 26, 27
Caroline class, RN 22, 24
Castor, HMS 22
Champion, HMS *19*, 20
Chapaev class, Russian Navy 59
Chatham class, RN 8, 9, 15
Chester, HMS 21, 23
Chester, USS 25
Chicago, USS 48, 56, *63*
Cleopatra, HMS 18
Cleveland, USS 52, 56
Columbia, USS *13*
Columbus, USS 56
Comus, HMS 22
Constance, HMS 22
Cornwall, HMS 15
County class cruisers, RN 31, 32
Courageous, HMS 24, 26
Crete 45

Danae, HMS 47
Defence, HMS 17, 21, 23
de Ruyter, RNN 46, 47
Des Moines class, USN 52
Deutschland, panzerschiff 34, 35,
 37, 38, 42
Dido class, RN 37, 45, 52
Dogger Bank battle 19
Dorsetshire, HMS 32, 42
Dragon, HMS 47
Dreadnought, HMS, battleship 8
Dresden, 11, 15, *19*
Dublin, HMS 17, 22
Duquay Trouin, French, class 31
Dunedin, HMS 42
Dupuy de Lôme, French cruiser
 7–8
Duquesne, French cruiser 31, 32

Edinburgh, HMS 37, 43, 44
Elbing (Ger. ex-Russ.) 19, 20, 22,
 23
Emden (i) 11–13, 15
Emden (ii) 34, 42
Emerald class, RN 26
Empress Augusta Bay battle 52
Esmeralda, Chilean cruiser 7, 8
Exeter, HMS 32, 41, *41*, 47

Falkland Is battle *11*, *14*, 15, 17
Falmouth, HMS 21
Fiji class, RN 37, 45
Fiume, Ital. heavy cruiser 33, 45
Frankfurt 19
Frauenlob 18, 22, 23
Furutaka 30, 31, 32, 49

Galatea, HMS 19, 20
Glasgow, HMS 13, 14, 15
Glorious, HMS 24, 26
Gloucester, HMS (i) 17
Gloucester, HMS (ii) 45
Gneisenau, armored cruiser 11,
 11, 13, 15, *15*
Gneisenau, battle-cruiser 42
Goeben, battle-cruiser 17
Good Hope, HMS 13, 14
Goodenough, Commodore, RN 18,
 21, 22
Gorizia, Ital. heavy cruiser *31*, 33,
 45
Graf Spee, pocket b-ship 35, 38,
 41
Grozny class, Russian navy 59

Harwood, Admiral Sir H. 38, 41,
 44
Hawkins class, RN 26, 28, 30, 37
Helena, USS 48, 49, 50, 51
Heligoland Bight actions 18, 26
Hipper, Admiral F. von 20, 21
Hipper 35, *39*, 42, *43*, 44, *54*
Hobart, HMAS 47
Honolulu, USS 46
Houston, USS 46, 47, 48

Idzuma 8, 46
Ikoma 8
Indefatigable, HMS 20, 21, 23
Inflexible, HMS 15
Invincible, HMS (i) 8, 15, 23
Invincible, HMS (ii) 62

Jamaica, HMS 44
Java, RNN 47
Java Sea battle 47
Jellicoe, Admiral Sir John 20, 21,
 22
Jemtchug, Russian cruiser 12, 15

Juneau, USS 50, 51
Jutland battle 19–23, *20*, 24

Kako 30, *30*, 48
Kara class, Russ. navy 55, 62, 63
Karlsruhe (i) 15
Karlsruhe (ii) 34, 42, *43*
Kent class, RN 15, 31, 32
Kenya, HMS *40*
Kiev, Russian navy *60*, 62
Kinugasa 32, 33, 49
Kirov, Russ. battle-cruiser 59, 63
Köln (i) 18
Köln (ii) 23, 34
Köln (iii) 34, *39*, 42
Königsberg (i) 15
Königsberg (ii) 26
Königsberg (iii) 34, *39*, 42
Kresta class, Russ. navy *58*, 61, 62
Kuma class 27, 29
Kynda class, Russ. navy 59, 61

Leander class, RN 36
Leipzig (i) 11, 15
Leipzig (ii) 34, 35, 42
Leningrad, Russ. navy 62
London class, RN 32
Long Beach, USS 59, 61, 62
Lützow, (Deutschland) 42, 44

Marblehead, USS 46, 47
Minneapolis, USS *50*, 51
Mogami class 35, 36, 37, 52
Monmouth, HMS 13, 14
Moskva, Russian navy 62

Nagara 50, 51
New Orleans, USS 51
Newcastle, HMS 36
Norfolk, HMS 32, 42, 44
North Carolina, USS 24
Northampton class, USN 32, 51,
 53
Nottingham, HMS 22
Nürnberg (i) 11, 15
Nürnberg (ii, 1933) 35, 42

O'Higgins, Chilean cruiser 8
Omaha class, USN 27, 28, *29*, 30,
 47
Orion, HMS 45

Pegasus, HMS 15
Pensacola, USS 31, *49*, 51
Perth, HMAS 47, 48
Pillau (Ger. ex-Russ.) 19, 21, *23*
Pola, Ital. heavy cruiser 33, 45
Portland, USS 50, 51
Prinz Eugen 38, 42

Quincy, USS 48, *50*

Raleigh, USS *29*, 46, *47*
River Plate battle *40*, 41

St Louis, USS *9*, *51*
Salt Lake City, USS 31, 32, 48, 49,
 53
San Francisco class, USN 7, 33,
 36, 48, 50, 51
Savannah, USS *54*
Scharnhorst (i) 11, *11*, 13, 15
Scharnhorst (ii) 42, 44
Scheer, pocket battleship 35
Sendai 27, 51
Sheffield, HMS 44
South Carolina, USS *57*, 62
Southampton, HMS (i) 22, 23
Southampton, HMS (ii) *35*, 36, 37

Suffolk, HMS 42
Suffren, French cruiser *33*, *56*
Sverdlov class, Russ. navy *58*, 59
Sydney, HMAS (i) 12, 13
Sydney, HMAS (ii) 44

Takao class 33, 35, 51
Tassafaronga battle 51
Tiger, HMS *60*
Trento class, Ital. 31, 33, 45
Trenton, USS *29*
Trinidad, HMS 42–3
Tromp, RNN 47
Troubridge, Admiral, RN 13, 17
Truxton, USS 61, 62
Tsushima battle 8
Tyrwhitt, Commodore, RN 18

Vincennes, USS 48
Virginia, USS *56*, 62, 63
Vittorio Veneto 61

Warrior, HMS 17, 21
Wiesbaden 19, 21, 23
Worcester class, USN 52

Yarmouth, HMS 24
York, HMS 32, 45
Yubari 30

Zara, Ital. heavy cruiser *32*, 33, 45

Acknowledgments

The author would like to thank
David Eldred, the designer,
R. Watson who compiled the
index and Richard Natkiel who
prepared the maps. The
following agencies supplied the
illustrations:

Marius Bar: pp 56–57
British Official: p 45
Bundesarchiv: pp 14–15,
16 (below), 18–19, 34, 39 (two
pics)
ECPA: p 33
Foto Drüppel: pp 22–23, 42–43,
43 (center)
Aldo Fraccaroli: pp 23, 61
Shizuo Fukui: pp 24–25,
27 (upper), 30
**Imperial War Museum,
London:** p 41
Marina Militare: pp 30–31, 32,
32–33
Ministry of Defence: p 61 (top)
Musée de la Marine: p 57 (top)
National Archives: pp 52,
53 (bottom)
National Maritime Museum:
p 40
Naval Photograph Club:
pp 16 (top), 46–47
Preston Picture Library:
pp 19, 26, 45 (top)
Maps © Richard Natkiel:
pp 14, 20, 21, 40, 44, 48
C & S Taylor: p 60
Ullstein: pp 38–39, 43 (top)
US Navy: pp 6–7, 9 (two pics),
12–13, 25, 27 (lower), 28–29
(4 pics), 36–37, 48–49, 49, 50–51,
53 (top), 54–55, 56, 57 (center),
58, 60 (top), 62, 63
PA Vicary: pp 16–17
Wright & Logan: pp 34–35